APERTURE

Connoisseurs and Collections

A small group of collectors and connoisseurs have played a significant role in shaping our understanding of photography. We are not speaking of those who would reduce the medium to a set of status symbols and commodities. Rather, in "Connoisseurs and Collections," the terms identify those rare individuals who, because of their passionate and often eclectic interests, their long-time involvement with and commitment to particular artists, or an almost archaeologically inclined curiosity, have brought together and woven into the very fabric of their lives collections that reveal their unique perspectives and discoveries. In this way, they are able to offer us a dynamic, intimate experience of the photographs they have gathered.

In the course of preparing this issue we interviewed six of the foremost private photography connoisseurs and collectors of our time, attempting to address the questions of why and how someone would go about amassing photographs. We selected individuals with varying approaches toward collecting, as well as varying focuses—some that demand substantial financial investment and others that do not. The interviews explore everything from the sport of collecting, that is, the competitive element, to the concept of a masterpiece. We tried to find out what criteria collectors generally apply. Is it a matter of historical precedent? Or is it the name recognition of the artist? Is it something else entirely? Where does content come in? And what about contemporary work? The question of vintage prints versus modern reprints of an older work came up in virtually every interview, underscoring the fact that—with photographs, which are in theory infinitely reproducible—authenticity, originality, and the artist's initial conception are of tremendous importance to the buying cognoscente.

The international collections featured in these pages—those of Werner Bokelberg, Gérard Lévy, Stanley Burns, Joshua Smith, Dorothy Norman, and Thomas Walther—represent a broad range of powerful, personal visions. Dorothy Norman opened up her home to *Aperture*'s photographer, allowing us a glimpse at her life and her passions. Our other collaborators worked with us to select images which, although they could not represent the scale and enormous diversity of the collections, do convey a sense of the collectors' interests, artistry, and desires.

As Arthur C. Danto suggests in his introductory essay, the very idea of collecting art is a peculiar one from a philosophical standpoint. Why is there this need to possess something as elusive and nonfunctional as a work of art? Harry Lunn, a prominent dealer in the international scene and one of the main orchestrators of fine-photography sales beginning in the 1960s, traces the history of collecting photographs, while Peter C. Jones—photography agent, writer, and editor—brings us up to date with the inside scoop on galleries, auction houses, and private dealers. Caveat emptor.

We asked Lunn and Jones each to put their expertise to work, first by picking three photographers (with the request that they focus primarily on contemporary artists) who they feel will be important to collectors in the years to come, and then by selecting a work by each of these artists to illustrate their choices: be on the lookout for Hot Pix.

Photography is still relatively young, and its acceptance as an art has come slowly. A number of major museums still do not consider photography for their permanent collections. Therefore, we must look closely at the collections of these connoisseurs, who have the imagination to see beyond the surface, faith in their instincts as well as in serendipity, and the belief in a value that transcends mercantile interests.

Perceptive collectors bring to their work a strong and distinctive point of view, which enables them to explore the possibilities in each individual photograph—in terms of both form and content—and then to integrate images adventurously. Each is gathering prints in a way that ultimately tells a unique story, revealing as much about the collector as it does about the photographs.

THE EDITORS

Featuring the collections of:

4 WERNER BOKELBERG

16 GÉRARD LÉVY

26 JOSHUA P. SMITH

36 STANLEY B. BURNS, M.D.

50 DOROTHY NORMAN

56 THOMAS WALTHER

2 FROM MATCHBOOKS TO MASTERPIECES:
Toward a Philosophy of Collecting
by Arthur C. Danto

46 HUNTER-GATHERERS IN THE AGE OF MECHANICAL REPRODUCTION
by Harry Lunn
with **HOT PIX**: photographers to watch out for

68 HIGH TIMES AND MISDEMEANORS
by Peter C. Jones
with **HOT PIX**: photographers to watch out for

71 PEOPLE AND IDEAS:
Image and Identity in War
by Robert Dannin
Photographs by Jolie Stahl

From Matchbooks to Masterpieces: Toward a Philosophy of Collecting

By Arthur C. Danto

Art collecting as a practice is at least as old as the practice of philosophizing about the nature of art, but nothing in the great canon of aesthetic writing, from Plato to Aristotle, through Kant and Hegel, to Nietzsche and Heidegger, would enable one to infer that art was something people might collect.

Much of what the philosophers have written implies that collecting art must almost be irrational, either because art is too inconsiderable to imagine anyone wanting to possess it, or too exalted to be bought or sold by anyone who understands its nature. Plato's theory of art as imitation, as slightly less ephemeral than mirror images, is meant to discredit works of art in such a way that wanting them makes no sense: who could conceivably have an interest in owning an imitation? It would be like wanting to possess a shadow! Kant, who thought of art primarily in terms of its beauty, analyzed the appreciation of beauty in terms of disinterested pleasure. But, in fact, interestedness defines the mentality of the collector, and wanting to possess seems as built into our relationship to art as it is into our relationship to someone we love.

"Monsieur le Prince de Galles," said Rubens of Charles I of England, "est le prince le plus amateur de la peinture qui soit au monde." (On the subject of painting, the Prince of Wales is the most knowledgable of all the princes in the world.) But Charles was not a disinterested aesthete: he purchased Rubens and the Raphael cartoons and the great princely collections of Mantua, and he got marvelous portraits from Van Dyck in exchange for a knighthood and a sti-

pend. The attitude of the French populace after the Revolution had appropriated the art of the aristocrats was that now all of this was *theirs*. Every self-respecting nation defines its identity through the treasures in its national museums, and negotiates tirelessly for the return of cultural properties. If Kant were right, what difference could it make where the Elgin marbles were housed?

Is this just one more instance of philosophy's chronic lack of awareness, of a piece with the fact that nowhere in its dense and abstract writing about human nature is it once noted that human beings are sexed, let alone gendered? Or is it due, instead, to the fact that collecting and possession are incidental to the essence of art? So many things are collected, the philosopher might say in self extenuation: matchbooks, baseball cards, beer bottles, stamps, coins, swizzle-sticks, pocketbooks, birds' eggs, seashells, mere stones. A collection can be formed of anything at all, and so of works of art, considered as tangible, visible entities. But Hegel considered art, along with religion and philosophy itself, as a mode of Absolute Spirit, as among the highest of spiritual embodiments. What, then, can art have in common with bottle caps if its true affinities are with metaphysics and religion? What could it say about the nature of philosophy that there are collectors of philosophy books? Or about the deep truths of the Koran that Muslim princes should collect rare editions of the book itself? The Koran could exist, does exist, in people's memories, and in their hearts. After all, the philosopher might conclude, there must be some reason why those who have the means—princes,

cardinals, the wealthy of the world—want to collect *art*. The French people hardly would have felt a sense of pride were some nobleman's collection of yo-yos appropriated and given over to them. Charles scarcely would have been lauded had he been an *amateur* of ornamental shoe horns! He would instead have been derided as dotty.

How characteristic of philosophy to regard as incidental to art the fact that works of art are material objects, embodied in paint or marble, ink or bronze, plaster or wood. You might as well say that it is incidental to our humanity that we have genitals and construe happiness in fleshly terms. But if material embodiment is actually part of the essence of art, then the radical indifference to this dimension of its being may not merely account for what has sometimes been described as the "dreariness of aesthetics" and the irrelevance of the canon to our experience of art. It may entail that philosophy has gotten it wrong from the beginning.

Let us consider that collecting, and especially collecting art, is one element in a complex of distinct institutional practices, all of which have to be in place to distinguish the process of collecting from that of merely gathering things together in one place, or accumulating objects. It is as if the entire complex arises as a whole, like a language, or a system of meanings. If this is true, then collecting art will be practiced only within those cultures that possess a kind of institutionalized art-world—those of Athens and Florence can not have been institutionally that different from SoHo and the Marais.

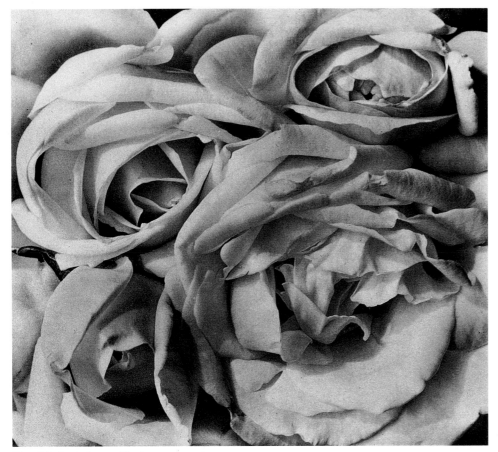

Tina Modotti, *Roses, Mexico*, 1925.
This image sold for a record $165,000 at Sotheby's in April 1991.

is easy to understand why philosophers, who think of art as exalted, must suppose its essence lies elsewhere.

In medieval Europe there was certainly the practice of forgery, not only of art but of documents, and especially of relics. There were those whose livelihood consisted of chasing relics down, and then an entire system of middlemen, who created a market in saintly fragments and slivers of the True Cross. These roles have their counterparts in the art world, which requires scouts and dealers, both of which must be acutely concerned with matters of provenance—giving further points of entry to forgers and connoisseurs, but clearly opening room for another discipline rarely addressed by aestheticians, namely, art history. The art historian is needed to determine whether an alleged provenance is *possible*, which means paying close attention to periods and individual styles. This means that out of the practice of collecting arises the concept of the artist as having a style and a historical location; with this come the familiar hedgings of the auction-house catalogue: "attributed to," "style of," "school of," and the like, which are variants on the theme of authenticity. And with this comes the question of interpretation and content. If everyone at a given time is painting apples or guitars, then we learn nothing about an individual painter by the fact that he paints apples or guitars—unless he was the first to do so. The search for precedents begins . . .

Because this process has become institutionalized in our culture, it is impossible to suppose it will not help form the consciousness of the artist, who paints (at least in part) to be collected, seeking to be the first, cultivating an individual style. Thus, collector and artist become aspects of the same reality.

Since collecting is not incidental to art in our culture, it should not be incidental to the philosophy of art—even if philosophers now and then envision a utopian society where art would exist free from the demands of "commodification." It might not be a bad idea to begin with the concept of collecting, and from there to move step by step toward an adequate philosophy of art.

Further, collecting can not be explained through instinct, as certain outwardly similar behaviors in the animal world must be. Not all cultures, not even those that possess an established artistic tradition, will have serious collectors. The sorts of concerns about works of art that define collecting as a practice—distinguishing between minor works and masterpieces, ranking works in terms of rarity or scarcity—do not necessarily arise in all cultures. These concerns arise from a conceptual atmosphere, and only someone who has internalized this atmosphere—and possesses the monetary means—can be a collector. Let me add that something of the same can be said about philosophy, which, as a formal practice, happens to exist only in cultures where art is collected. I will go further, and suggest that there is a deeper connection between philosophy and art collecting than may at first appear.

The moment there is collecting, two types of individuals are immediately implied—the forger and the connoisseur. The forger is skilled at getting objects into collections under false pretenses, by getting them to look authentic. If the distinction between the genuine and the bogus did not exist, there would be no forgers, but neither would there be collections, since collections are by nature exclusionary. There would be no philosophers, for philosophy is unthinkable without some discussion of the distinction between appearance and reality. Meanwhile, the connoisseur is skilled at keeping out of collections the fabrications of forgers, by cultivating knowledge of the differences between the apparent and the real. Where this distinction does not penetrate the culture, there can be art, but not the collecting of it. Because the specter of illusion, of false identity, hovers over the elements of a collection, it

The Collection of
Werner Bokelberg

Aperture: When and how did you start collecting?
Werner Bokelberg: About twenty years ago I began to gather photographs. It was an era that might one day be referred to as the best time to build a solid collection. In spite of, or perhaps because of, the ease of reproduction, photographs were much more scarce than I expected. Knowing that they could reproduce photos on demand often kept photographers from printing several prints at the time they made the original negative.

But I first developed an interest in photography as an art form by looking at daguerreotypes. I started collecting them. Before long, though, it was virtually impossible to find great examples. The market had dried out.

In the course of my search I became interested in works on paper. I bought my first Hill and Adamson and began collecting the English masters. I soon realized that nineteenth-century France also produced great material. I started to look for works by Charles Nègre, Nadar, Henri Le Secq, Charles Marville,

I don't think that there is a complex philosophy on how to build a collection. You start, and if you are sincere there is no way to stop.—WB

Edouard-Denis Baldus, and others. Whenever there existed a salt print of an image that I was looking for, I tried to acquire it. The quality of a print has always been very important to me. Only excellent preservation of the most beautiful rendition of colors and freshness let us experience the third dimension, the object the photographer really intended to show.

Of the photographs that crossed my path, I tried to hold onto the ones that haunted my thoughts the most. Looking at what had become a collection, I felt the need for a contrast to the subtle dignity and beautiful tonality of the early material. This is when I expanded to the more glamorous, perhaps more intellectual works of the early twentieth century. Up to today, no photograph taken after 1940 has entered my collection.
A: How would you define the quintessential collector?
WB: To be a collector means that you have no choice if you find that image of desire. You have to acquire it, if it fits into the mosaic that you are creating. There is no way of denying it.

I do not feel I can add much to my collection. I am happy if I find one or two photographs a year. Although I would love to come across an 1840 Bayard, an early Le Secq still life, a Coburn Vortograph, or a 1915 Strand. But I am also open to surprises the future may have to offer.

Unfortunately I can not surround myself with the photographs of my collection. I believe them to be too fragile to withstand permanent exposure to light.
A: Is there anybody else whose work you'd consider collecting?
WB: I very much enjoy a lot of Ettore Sottsass's ideas, and have a small collection of his work.
A: Did you start collecting with a vision and stick with it, or has your philosophy evolved along with your collection?
WB: I don't think that there is a complex philosophy on how to build a collection. You start, and if you are sincere there is no way to stop. You just have to add what's great; and you have to find the means to pay for it. By being patient, nearly every great image you think about will find its way into your collection. You are basically working for the museums. Sooner or later every private collection will be with the public.
A: And what about the question of connoisseurship?
WB: You just have to look at as much as you can, and of course at the best work available. That way you know great pictures if you come across them.
A: Do you think there is such a thing as a masterpiece?
WB: I do. It will speak to you when you see it. It has more dimension. It is the print and paper quality, and the object's character that make it stand out.

Nevil Story-Maskelyne, *Hands*, c. mid 1850s

Giacomo Caneva, *Italia*, c. 1854

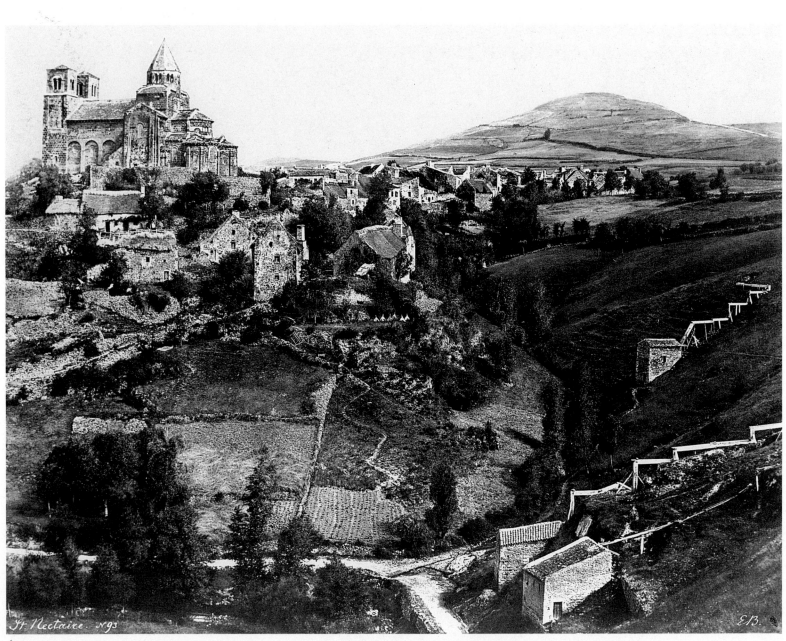

Édouard-Denis Baldus, *Saint Nectaire*, no. 93, 1854

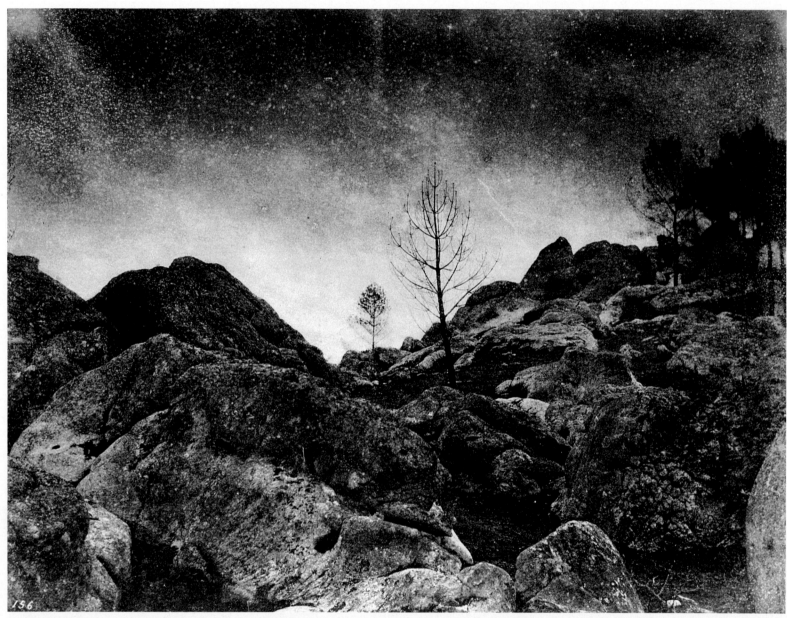

Eugène Cuvelier, *Paysage de Fontainebleau, L'Orage* (Fontainebleau landscape, the storm), c. 1860

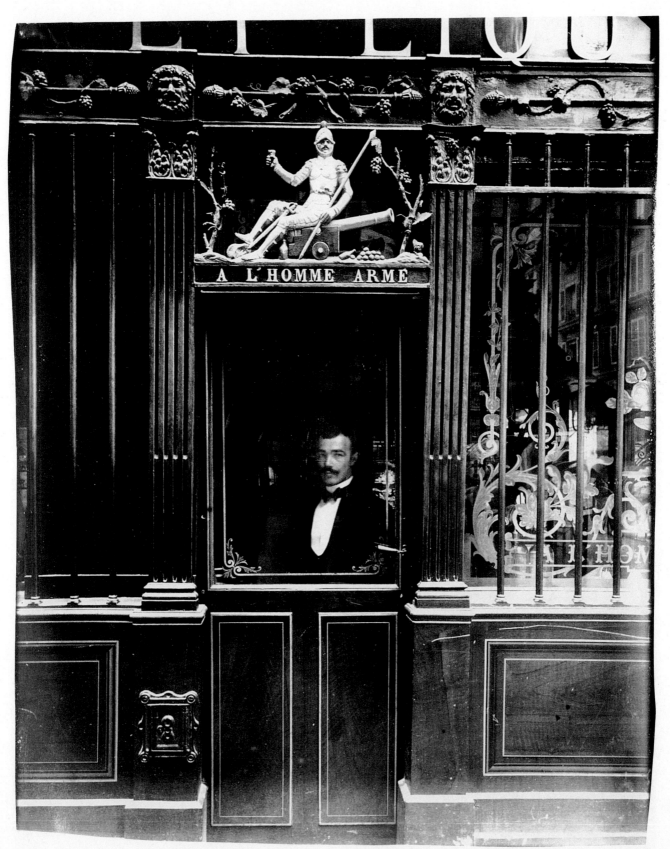

Eugène Atget, *Cabaret à L'Enseigne à L'Homme Arme, 25 Rue Des Blancs-Manteaux*
(Cabaret at the sign of the armed man), c. 1900

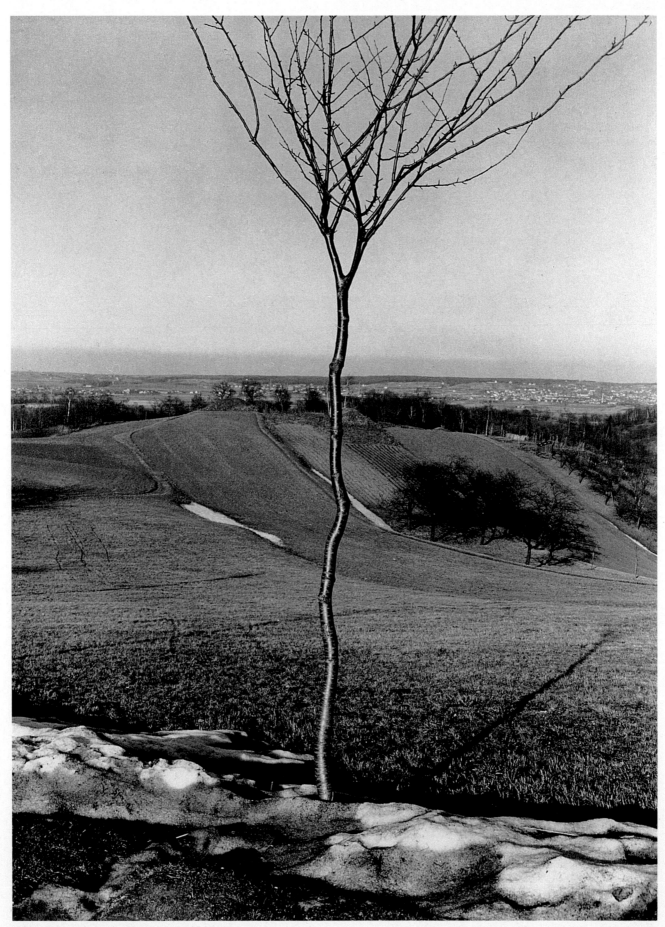

Albert Renger-Patzsch, *Baum Im Frühling* (Tree in spring), 1928

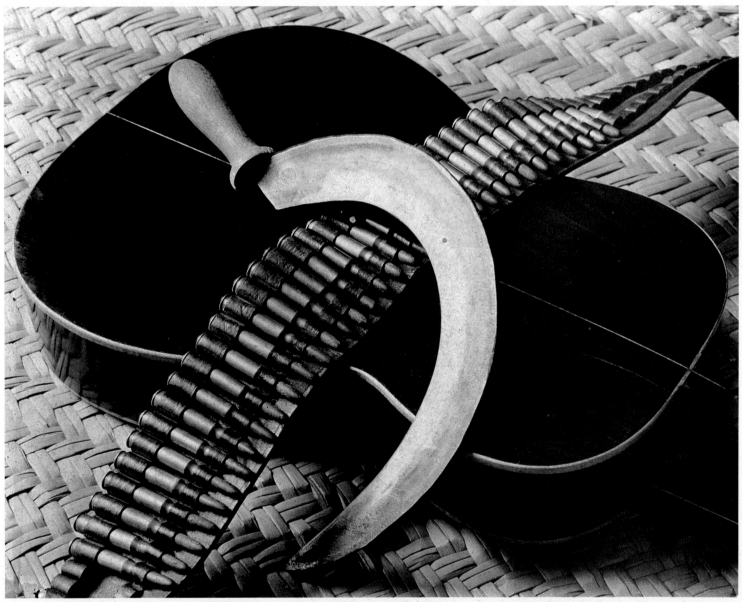

Tina Modotti, *Falce, Cartucce, e Chitarra* (Sickle, cartridges and guitar), 1927

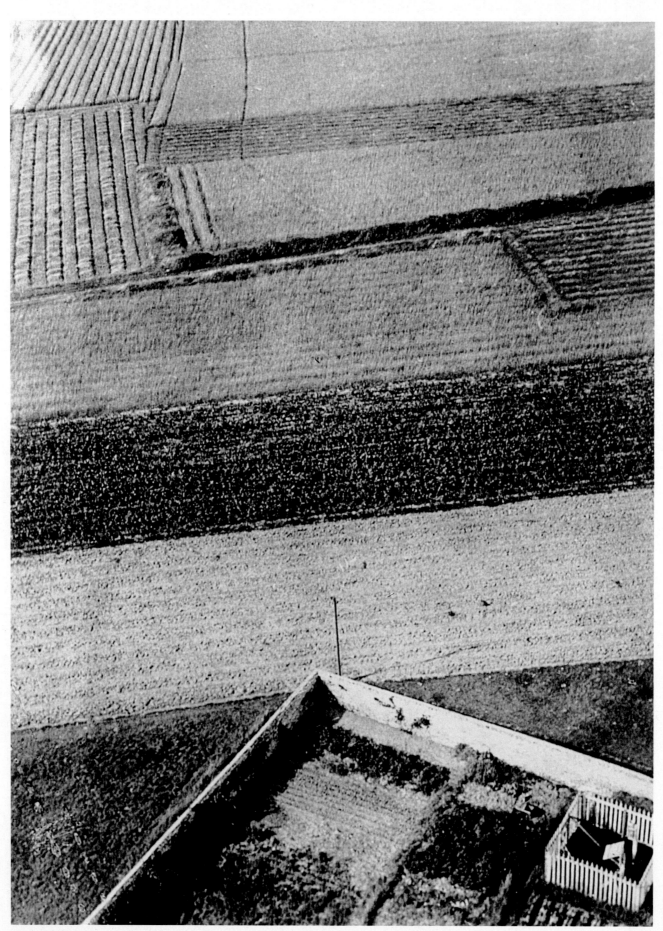

László Moholy-Nagy, *Ackerfelder Auf Belle-Ile-En-Mer* (Farmland in Belle-Ile-En-Mer), 1925

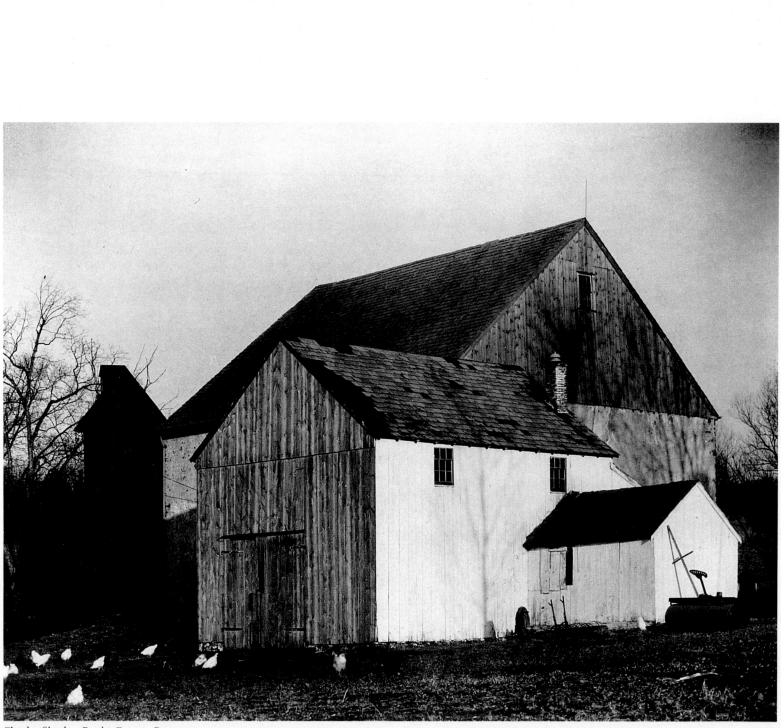

Charles Sheeler, *Bucks County Barn*, c. 1917

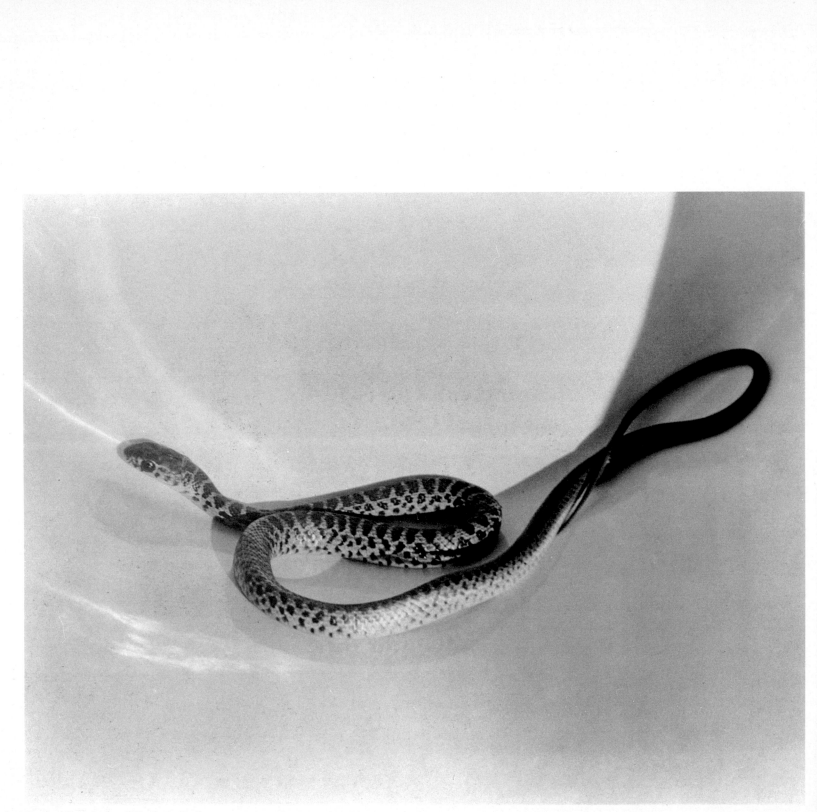

Imogen Cunningham, *Snake in Bucket*, 1929

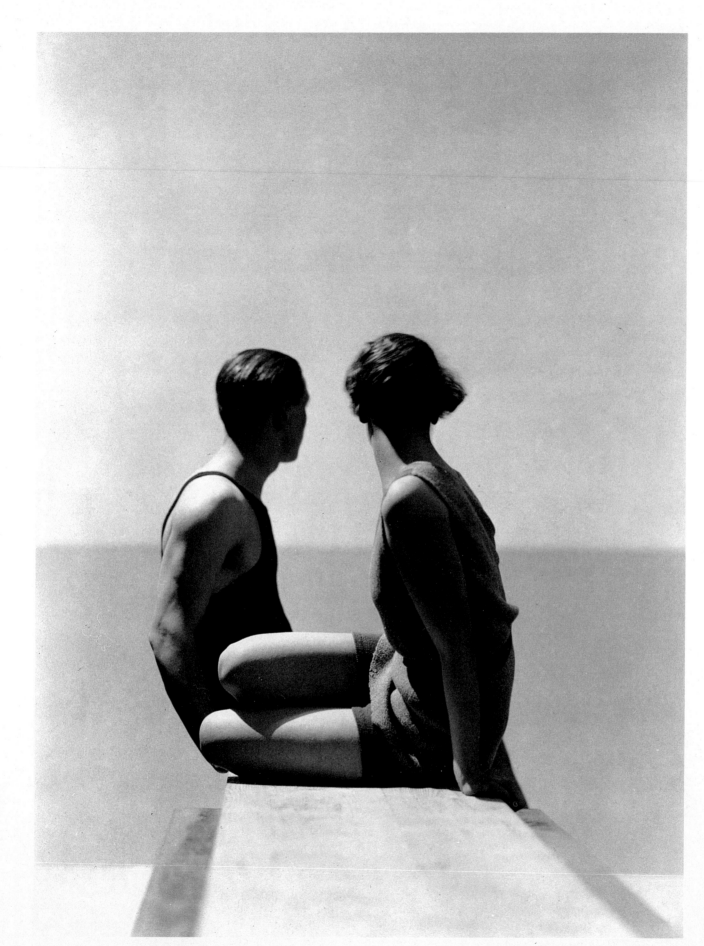

Hoyningen-Huene, *Costume A.J. Izod, Paris, April 18,* 1930

The Collection of
Gérard Lévy

Aperture: Tell me about the people who collect.

Gérard Lévy: A collector must be mad, because a collection is something no one needs. You are following some line of thought and mixing images—it is an art of love. If you don't know why, then you are collecting things because they somehow go with one another. In the twentieth century, a collection begins when you have two things; when you have one thing, you are not a collector. I believe that collecting is a personal expression—the deepest part of yourself you show to others. Even if you don't know why you're collecting, someone else could tell you. The collection is a revelation of yourself.

A: What part of yourself do you think is revealed in your collection?

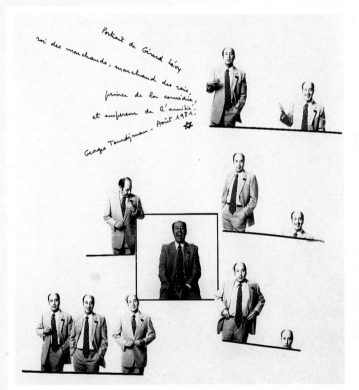

Georges Tourdjman, *Gérard Lévy*

A collector must be mad, because a collection is something no one needs. —GL

GL: My love of life. In collecting photography, you look through the eyes of the photographer and maybe you see things that he has not seen, and that's what interests me. You dream, you jump in; it's like diving in the water. A collection is a distortion.

A: How does it become a distortion?

GL: You see things that the photographer has not seen. You can travel by your photographic eye—photography is a dream. This is my Surrealist vision. The collector is a dreamer, one who looks outward and beyond. I am not speaking about an investor; an investor sees the art just in terms of himself. Here's a story: a rabbi was interested in raising money to give to students, to broaden minds. So he went to see a rich man and asked for some money; the man gave a few dollars. The rabbi asked, "Can you give me a few moments more?" "Certainly," said the man—he was a very high rabbi. "Please go to the window," the rabbi said. "What do you see?" "I see cars, a woman with a dog, and so on." Then the rabbi said, "I know there is a mirror in your room. Look in the mirror and what do you see?" "I see myself," he answered. "Naturally," said the rabbi, "because there is silver. With the window, you look outward and there is no silver behind, so you can see everything. When there is silver, you see only yourself." And that is the same with investors. They ask, "How much profit can I make on this?" They see the silver; they see only themselves.

A: What do you collect for yourself, to live with?

GL: Well, I collect bizarre photographs, in the mood of the Surrealists. I also collect photographs of nudes. I love life, and woman is part of life. I am impressed by the big American landscapes by Carleton Watkins. I love daguerreotypes. I have always loved them. My wife asked, "Do you know why you love daguerreotypes? Because they are objects, collectibles." I am a sensual person, and daguerreotypes have a special quality. You don't touch a daguerreotype, you play with it. When you look at a daguerreotype, you try to get in, to peep in, to dive in.

A: And how do all your works relate to one another? Do they?

GL: The collection is like a puzzle that needs to be solved. Nobody's objective. I am not objective. But you attempt to show what is in the objects you assemble. Of course, it's complicated with photography, but if it's a good photograph then it's always a good photograph. If you want to collect masterpieces, then you must get to know the artist's speciality.

A: You seem to believe that collections are largely about who the collectors are. Do you think about that when you advise people on their collections?

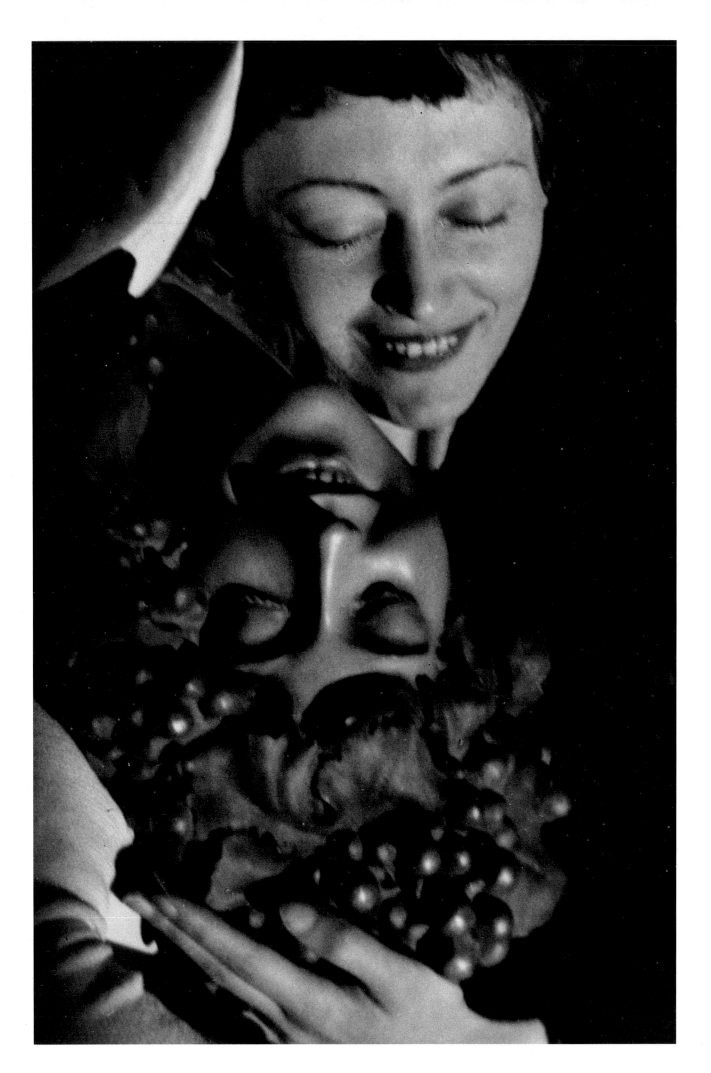

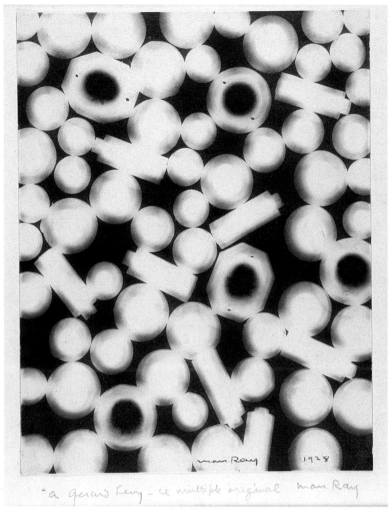

Man Ray, *Chandelier Crystals*, Rayograph, 1928

As an antique dealer and a collector, I love vintage works, and I don't understand paying high prices for modern reprints of photographs.

GL: Not always, but I will give you an example. When a collector comes to me for advice, I take time to show him ten to twelve pictures that I have chosen, based on whatever information he has already given me. Out of the ten to twelve pictures, this person will pick one or two. Since I make a selection that is already the cream of the crop, they can't go wrong. I always choose the best works, because I choose what I believe in. I do that with every collector. And the more you know the person, the more you know what they like, and the more you make the link. Naturally, I like money, but I don't speak of money. My pleasure is in my prints, in my collection. If someone said, "Give me a billion-dollar collection," I don't think I'd like to do it. When people say they want to see a print by Henri Cartier-Bresson, I ask, "What do you know about Cartier-Bresson?" Be open, say you want to know different aspects of the photographer's life. People change. Photographers may work for thirty years. Happily our appreciation changes too.

A: Do you think that collecting—especially in photography— has helped shape the medium? That our appreciation of art has been influenced by the way people collect or deal?

GL: Absolutely. But collecting modern prints of an old photograph is different. As an antique dealer and a collector, I love vintage works, and I don't understand paying high prices for modern reprints of photographs. They're not the originals, it's not the photographer's original vision. A picture taken in 1930 had a special look, and the printing was typical of the times. A picture from 1930 printed in 1955 would be absolutely different from the look of the original. The paper and chemicals are different. And that's why I love vintage prints. And photographers are not all innocent. They understand the weight of an original. Brassai, Man Ray sometimes made only two or three prints, although this was probably because they had no money. A collector, as I told you, is a madman, and he needs to have the original of something. Maybe I am too sophisticated, but I know what I like—the unique object.

Many people want only well-known images. Why? Because they can make money off them. But that's not a collection. The collector has to make his own mark, leave his own signature, and hopefully uncover the photograph that has never been seen— the unknown. That is the true art of collecting.

Man Ray, *Bouchons de Carafe* (Stoppers), Rayograph, 1922

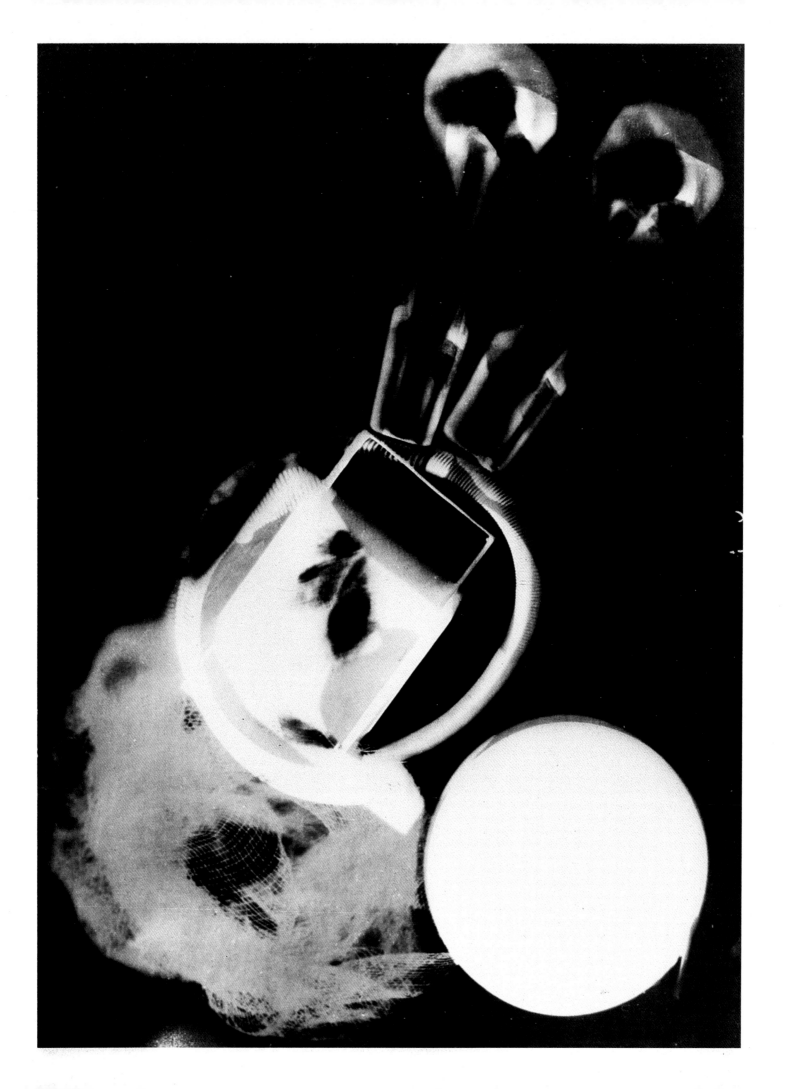

Man Ray, *Brogna Perlmutter-Clair, Ciné-Sketch: Adam, Eve,* 1924

Man Ray,
La Marquise Casati,
prise lors d'un bal chez le
Comte Etienne de Beaumont
(The Marquise Casati, taken
during Count Etienne de
Beaumont's ball), c. 1926

In collecting photography, you look through the eyes of the photographer and maybe you see some things that he has not seen.

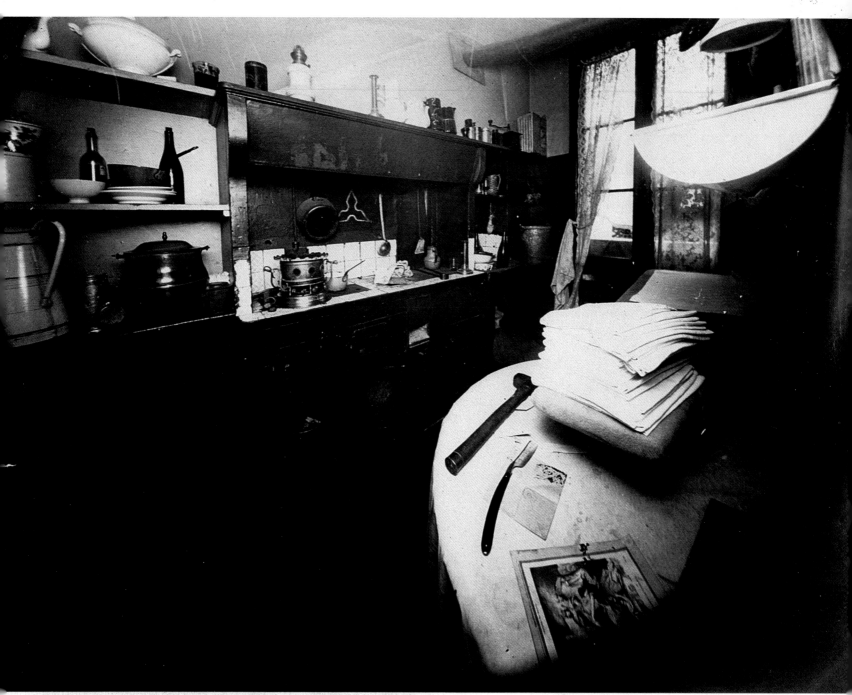

(Above) *Affaire Peugniez-Assassinat, 5 Juin 1898, "Vue de la Cuisine."* (The case of the Peugniez assassination, June 5, 1898, "view of the kitchen")

(Left) *Assasinat du jeune Gregoire Pierre, dit le "Petit Pierre," le 14 Décembre, 1896 "Cité Vanneau-Endroit ou l'enfant a été trouvé"* (Assassination of young Pierre Gregoire, called "little Pierre," December 14, 1896, "Vanneau city, place where the child was found")

(Page 24) *Assassinat de la Dame Durand— Rue Lafontaine, "Vue de la chambre à coucher"* (The assassination of Lady Durand, rue Lafontaine, "view of the bedroom")

(Page 25) *Assassinat de le Dame Veuve Caron, Marchande vins, 1er Mars, 1900, "Vue de la boutique interieurement"* (Assassination of the widow Lady Caron, wine merchant, March 1, 1900, "interior view of the shop")

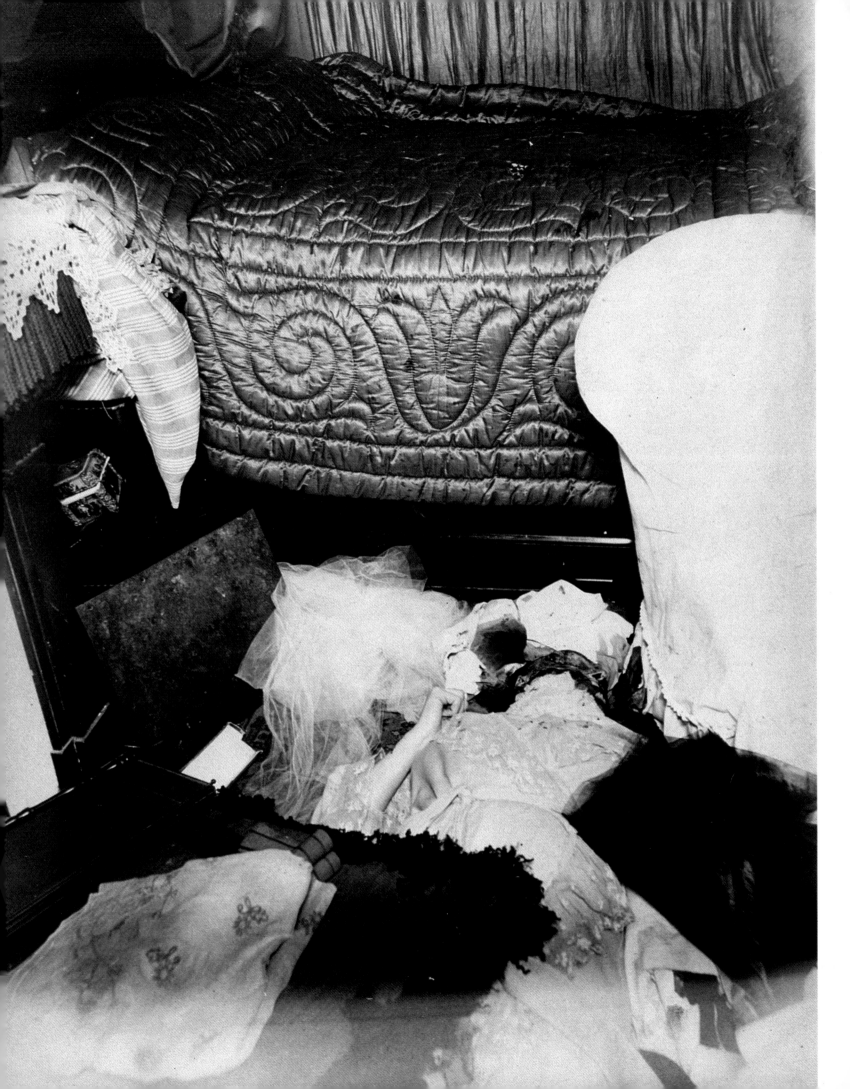

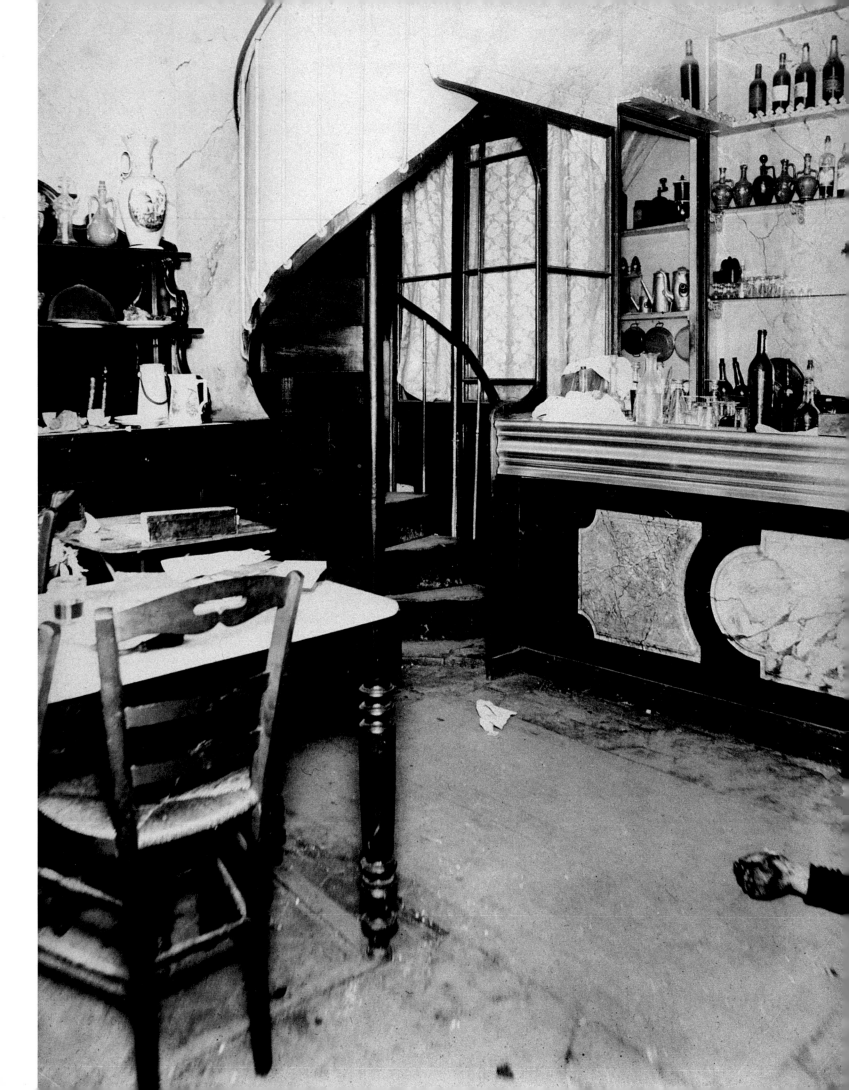

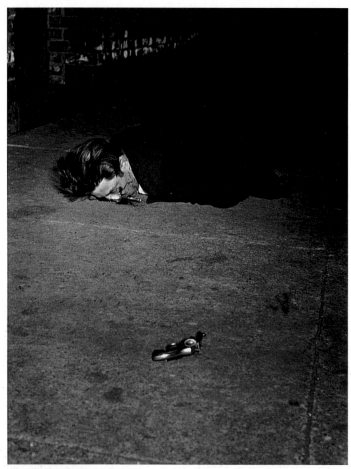

Weegee, *Corpse with Revolver*, 1940

Cindy Sherman, *Untitled Film Still #34*, 1979

The Collection of
Joshua P. Smith

Aperture: Do you consider yourself a collector?

Joshua Smith: I've been a collector for over twenty years. This means that I'm interested in art. I buy art not just for the purpose of decorating where I live and work, but with the idea of assembling a collection, that is to say, meaningful bodies of work that in some way have a relationship to one another.

A: How would you describe your collection?

JS: It's hard for me to talk about a single collection, as I collect in several different areas. I started out in photographs, and then I went more heavily toward American prints of the first half of the twentieth century.

A: Why did you make the transition?

JS: Well, I started off with photos. I think I had grown up influenced by the fact that my uncle was a photojournalist—Dan Weiner. When he was included in a photography show done by Cornell Capa in 1967, "The Concerned Photographer," I was invited to the exhibition opening at the Riverside Museum, and that was the first time I had been to a formal exhibition. I then got

I don't have any consultants or advisors. I obviously talk to people, but to use a cliché, you should buy art with your eyes and not with your ears.

on their mailing list and received a notice for another photography show by Laura Gilpin and went to that. Then the Witkin Gallery opened in New York and I went for the first time and bought a Harry Callahan photograph. So the first photograph I had in my hands actually was a Harry Callahan photo. I got involved in collecting by being interested in photographic imagery in magazines; it wasn't an art-influenced thing, it was image-influenced.

A: Did you consider yourself, at that point, a collector?

JS: At that point I didn't consider myself a collector. I didn't know what art was, really. I just happened by instinct and chance to acquire a few photos. It was after I was unable to keep the work in my small apartment—it started to get rather crowded—that I understood what collecting really was. Collecting could be defined in two practical ways. One way would be when you own more than you can hang. The second is when you get it for yourself, and you think only secondarily about how it should be displayed. That is not to say that people who hang everything or just don't collect a lot cannot be collectors. In my case I collect very large quantities and I never think about display or hanging.

A: Why did you make the move to prints?

JS: I had started out with photos in the 1960s, and then in the '70s I realized that the photo field had become popular, and prices, although still very low, had risen dramatically. By chance I happened to notice some works in some small print places by Ameri-

Marc Riboud, *Prague*, 1981

W. Eugene Smith, *Haiti*, 1958–59

Garry Winogrand, *American Legion Convention, Dallas*, 1964

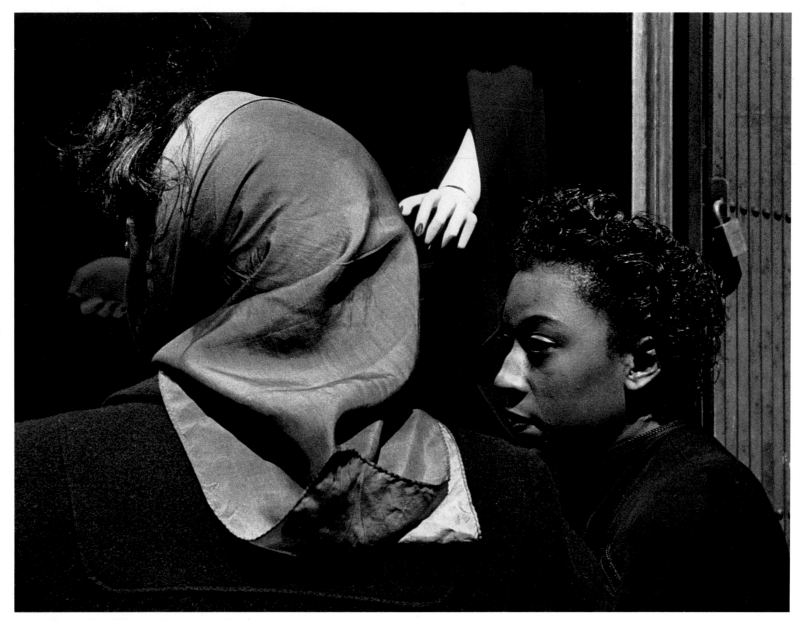

Roy DeCarava, *Two Women, Mannequin's Hand*, 1952

can artists which were very inexpensive and very good. I found that I was attracted to this kind of work and could also pay much less money buying lithographs, sometimes etchings or drypoints, than buying photos. So I really started to do more collecting of American prints than I did of photos.

A: You went from photos to twentieth-century American prints, and then you went back into photography?

JS: I went back into photography later in the 1970s.

A: What time period did you focus on? Were you getting more contemporary?

JS: In the early '70s I had the entire history of photographic work in my collection. I had gotten some work from the nineteenth century, such as Julia Margaret Cameron and Eugène Atget, and I was also getting contemporary prints at the same time, but not in any great quantity. It was only in the late '70s that I started to collect photography and collect in great quantity. By that time I had found that print prices had risen to a point where everything

was now expensive, and during a trip out to the West Coast I got entranced by some new color photography that was being done.

A: Such as . . .

JS: Richard Misrach and Arthur Ollman. In general I opened myself up to all kinds of new work. I had stopped collecting photography in the mid 1970s. It's hard to describe, but after several years of collecting photographs, when other people started collecting, it took the fun out of it. I approached photography instinctively. I had no idea why I was collecting when I went to the first shows, the first auctions in the '70s. I went to all these things first and I felt it was really new; there was a sense of discovery. And then the field started to be filled with a second wave of people who were developing it into a market, and prices were rising.

A: Do you think that's because so many new galleries had opened that were dealing this work, or do you think people just discovered the works' intrinsic value?

JS: I think it was both. I think there really was a difference—

photography was something that wasn't valued in general; prints were valued but only the kind of modern European prints you'd see at MoMA: Picasso, Miró, Matisse. Prints by American artists were looked down upon. I think the rise in prestige in collecting American prints came about probably because of a greater interest in American art in general.

A: Do you get advice from anybody? Your print collection is phenomenal.

JS: I don't have any consultants or advisors. I obviously talk to people, but to use a cliché, you should buy art with your eyes and not with your ears. In the last few years, however, I have drastically curtailed buying prints.

A: Why?

JS: Again, because I felt that there was too much hype. It was clear to me that a great many prints were being produced for the market and not by the artist as his or her own desire to fulfill a certain idea.

I am very intense in the way I look at things and I expect the same intensity in the artist's approach to his or her work.

This goes back to the general idea of what my collection is. I am able to judge a work's quality on the basis of how closely I can discern the artist's ideas and expressions. I'm able to get very close to the artist and to feel directly the artist's conception. That may be one reason why many of the prints I collect are unique or in some way have a hand-made or rougher look than a very high-tech look. I like work that is strong rather than decorative, work that has an edge to it. I really can sense and share the feeling of artistic creation.

A: Do you meet many of the people whose work you collect?

JS: I meet a fair number, but it would be wrong to say that I meet most of the people I collect. I very much enjoy meeting artists; I think that they enjoy meeting me. We usually share a lot of ideas. Mostly I enjoy it when it gives me an idea about the creative process that artists go through when they make work. I believe in collecting artists, in looking at an artist's body of work in the studio, even things that have been rejected or that they're afraid to show me, so I understand the whole process of how the artist has produced the work, the sequencing, where it's been, where it's going.

A: It's always interesting for me to know what an artist's favorite work is.

JS: It's nice to know that, although I rarely agree with the artist. When there are bodies of work or series, especially in photography, I think it's important not to look for the single image, but to understand what that body or series is, and, if possible, to get several works from that series. I always resist the idea of a masterpiece, the Wagstaff view of looking at individual photos as masterpieces. To my mind, it subverts the idea of the photographer as artist. I think a photographer is an artist just as much as a painter or sculptor is. There can be wonderful photos taken by amateurs and unknowns. I'm interested in a more thorough exploration of a

Lisette Model, *Bud Powell*, 1950

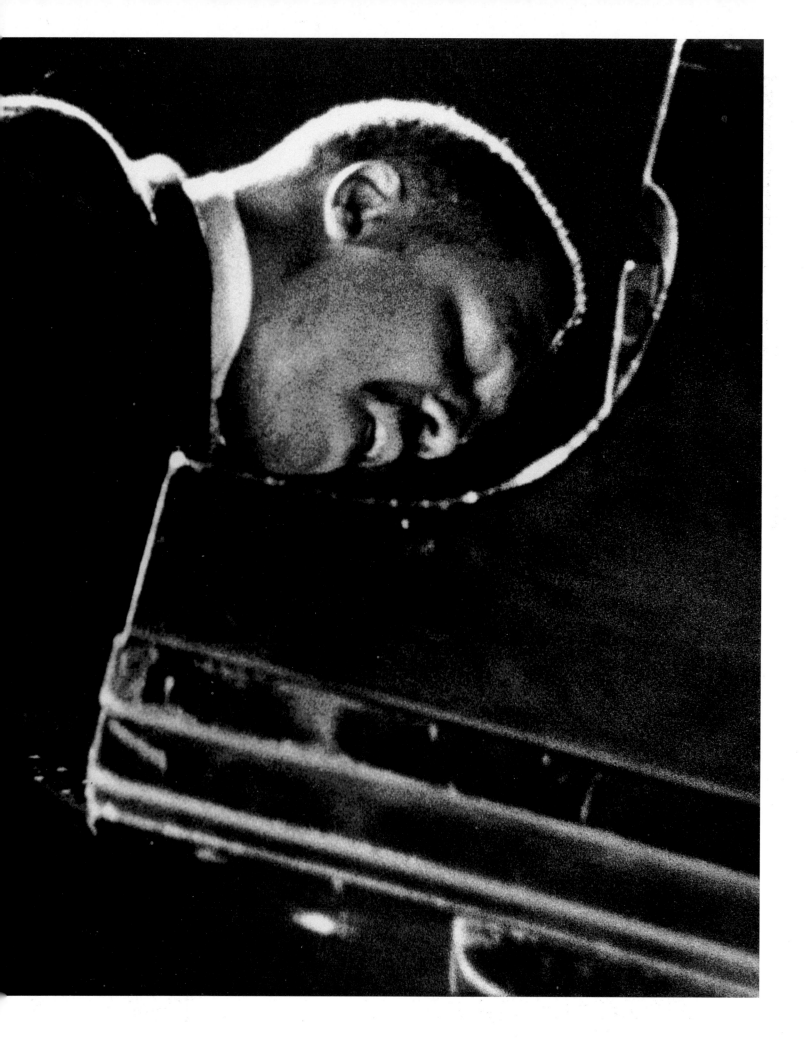

Bill Dane, *Los Angeles*, 1982

William Klein, *Modern Dance Ceremony, Tokyo*, 1961

photographer's work as an artist. I would rather have a dozen photos by one artist than by twelve different people.

A: Are you interested in works from the same time period or spanning an entire career?

JS: It varies. I prefer to collect several pieces within one body of work than to collect highlights of works over a person's career. I like to make a certain clear connection between myself and the artist's idea of what he or she is doing. I am very intense in the way I look at things and I expect the same intensity in the artist's approach to his or her work. My collection is comprised of several components. I have a collection of contemporary prints, I have a collection of early-twentieth-century American prints, and I have a collection of contemporary paintings and drawings. But with photography, it's not defined as neatly as in the other areas. It goes from the 1850s to the 1990s and it spans all nationalities and all different styles. Photography has been the area where I have instinctively collected without specific ideas in mind about what the scope of the collection should be. But my main passion has clearly been work from the last fifty years and, accordingly, my collection of contemporary photography is quite remarkable.

A: Do you collect work in several media by the same artist?

JS: Yes. Very extensively. For example, I have prints, drawings, paintings, and photographs by Brian Wood. Prints and photos by Paul Nash. Prints and objects by Vito Acconci, and so on. I also have many drawings related to prints, paintings, or photos in my collection.

A: And this is also about your commitment to these people as artists, and their thinking?

JS: Absolutely.

A: Do you think there is such a thing as a masterpiece? Are there images that are somehow superior?

JS: I think there really are some masterpieces, but I think too much is made of it, particularly with photography. I mean, just simply to replicate the images in Beaumont Newhall's *History of Photography* or *Masters of Photography*, or any other book of that kind, ruins the whole idea of collecting. You may as well just have the book, you don't even need the photos. It becomes like collecting stamps rather than art.

We are faced with the troubling practice of reducing a whole career to maybe a dozen images. I do think that there are such things as masterpieces but I try to resist the idea. It's not to say that I won't get one of the eight or ten "masterpieces" by a particular photographer, but it certainly is not my objective to make a list of the master photographers and their masterpieces.

A: How do you choose the artists you are interested in?

JS: I'm interested in artists that move me, that have something to say, that are serious, committed. It's hard to describe in a way that other people can follow. I think in some ways sensing the quality of artwork in addition to having a good eye is something one has pretty naturally and can develop only to some extent. I feel fortunate to have—without planning or academic training—developed this gift by lots and lots of looking to the point where I can tell which things are really true and moving.

I like work that is strong rather than decorative, work that has an edge to it. I really can sense and share the feeling of artistic creation.—JS

A: What photographers are you now collecting?

JS: I have significant collections of Garry Winogrand, Lee Friedlander, Robert Frank, Nick Nixon, Louis Faurer, Wright Morris, Peter Keetman, Albert Renger-Patzsch, Harry Callahan, Aaron Siskind, Berenice Abbott to name a few. It's hard for me to give all the names because I have several images by dozens of photographers.

A: Where do you think connoisseurship is exemplified, or an issue, these days?

JS: I think that we have come to a time where many art critics and museums act like dealers. They take something that fits a certain category and present it, in a marketing sense, and lack the true conviction to choose what's good. They want to show what will draw attendance, and what will please donors, sponsors, and board members. I think that in the New York art scene over the past ten to fifteen years, museums have tended to present contemporary art as an extension of the market place, and what's most lacking is a distance from the market place. Perhaps not living in New York gives me a little more perspective. I don't have to succumb to all the pressures and be immersed in what goes on in New York, although frankly the vast majority of things that I acquire will come from New York. I think that really is a problem. In the earlier decades, we felt from the Museum of Modern Art a certain sense of connoisseurship, that they were the leaders in defining the work in those time periods and categories. In the past twenty to thirty years, this role has not been taken up by any New

William Eggleston, *Outskirts of Morton, Mississippi, Halloween*, 1971

York institution. As we've seen clearly from what's happened at the Whitney, a sense of perspective and connoisseurship has been replaced with what's in line with the market.

A: Are we seeing a conflict of interest?

JS: To some extent. But I am not so much concerned with conflicts of interest as I am with just taking the easy way out. You don't have many museums and curators working with sufficient seriousness and conviction. They may not be able to get a show mounted or catalogued unless someone will provide funding. There may be all kinds of reasons why they can't do certain things. Whether it's the general surveys or the Biennials, we don't find museum exhibitions that take serious and independent curatorial positions and that we have confidence in. You talk about masterpieces. I just can't say from what the New York museums have shown in the last decade that we know what the masterpieces are. We know what has been promoted and marketed.

A: You have curated shows yourself.

JS: I got involved in working on an exhibition of my contemporary print collection at the National Gallery, and shortly afterwards I also was invited to curate a show on contemporary American photography at the National Museum of American Art called "The Photography of Invention." I found that I was able to, in curating, have more access to works of art than if I had to buy them. Today I find myself much less involved in collecting and very much involved in curating.

A: Why is that?

JS: In some ways the collector played a more dominant role than museums and galleries did in the 1980s. To be a collector in the '80s was to be almost in the highest position in the art world. Maybe it was an unduly high position. If we think back to the '80s, it was a time when the collector took over. It felt like our definition of what was good and the artists who seemed to us worthwhile were driven more by the collectors than by exhibitions. That these things were shown in museums was a confirmation of what had already been collected privately.

A: So the museums were no longer on the forefront?

JS: Most of the artists had already been established by collectors. So with the explosion of art and the new directions in the 1980s, being a collector was probably the most exciting way to discover new artists—in Europe, in the East Village, in SoHo. The explosion in photography by painters and sculpters was generally missed by the museums. In fact, one of the reasons I did "The Photography of Invention" was I felt that photography departments were missing the boat in not acknowledging the major role that painters and sculpters play using the camera for purposes that are not straight photography.

Now, with the art market as it is, curators and museums will have to play a greater and more independent role, relying less on the market and collectors and more on resourcefulness and connoisseurship. I hope to continue to contribute to this process by making my collections known to a wider audience and by expanding my curatorial activities.

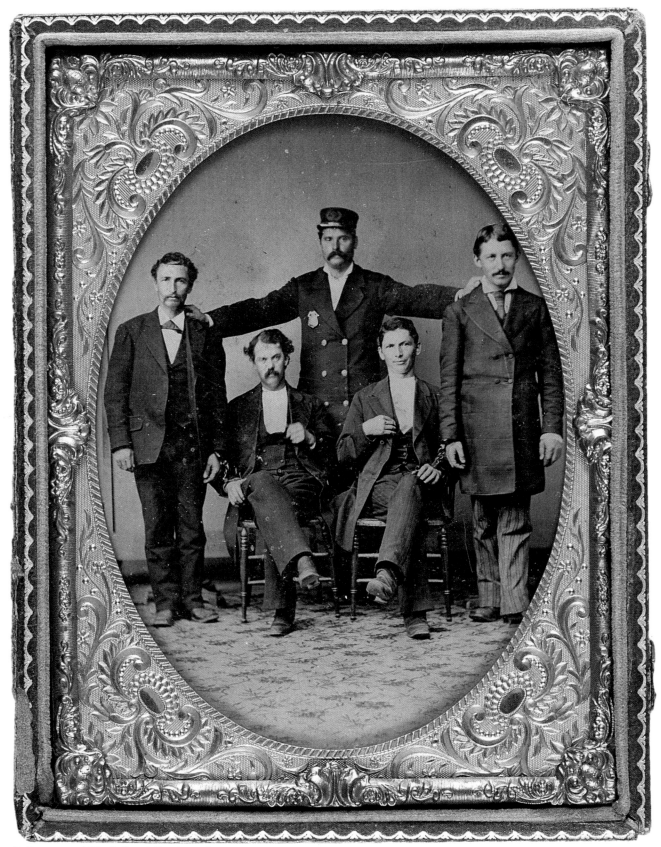

Policeman and His Collared Captives, 1870

Stanley Burns: I have over 125,000 photographs. My collection is best known for its medical photographs, of which there are over 25,000 original images from between 1840 and 1920. I also have original Civil War albums, and copy prints of them are in government archives. Then I have about two thousand daguerreotypes, including historical and documentary pictures as well as beautiful portraits. Another large area of my collection is black Americans. I have one of the largest collections of early black American photography. When I say early, we're talking 1840 to 1870. There are larger collections on blacks, but they are of a later era.

My Judaica collection includes over three thousand prints and some daguerreotypes. I also collect "folk photography," a term I coined in the 1970s to describe photos that melded early photography with the work of naive painters. I also have a collection of early photographs of police and criminals. You see, there was a tie between psychiatry, medicine, and criminology during the nineteenth century.

Aperture: Well, wasn't there some theory that if someone had large ears or tattoos . . .

SB: People were able to identify them as criminals. And this was based on the theories of physiognomy and phrenology. This was the era of identifying personality traits through physical characteristics and facial characteristics, which obviously doesn't work. But I do think that today we place a great emphasis on environment as a cause of everything. What's going to happen is that one day they'll show that environment accounts for a small percent of development and genetics accounts for most of it. People just don't want to face it. There are too many implications. And they're finding the same thing with disease. Much mental illness is now believed to be caused by a chemical imbalance. Also, did you know that the first use of germ warfare was smallpox-infected blankets given to the Indians during the war? I am not making this up.

A: I'm not doubting you, they are just things I've never heard about before.

SB: If you knew about these things, if they were common knowledge, if they weren't absolutely amazing facts about medicine and science, I wouldn't be writing about it. What I do is I use my photographs to gain the big picture of history. I like history because it's only in looking at history that you can get to the truth. I look at vintage photographs as documents, to see what actually happened in America. In my book, *Sleeping Beauty: Memorial Photography in America*, I make the statement that most of the issues in our country, except poverty and violence,

are death related: abortion, AIDS, euthanasia, the death penalty. And people are out on the streets trying to kill each other over these issues. We're afraid of death in our society; we don't want anything to do with death. It's a twentieth-century taboo. So what I do with my photographs is use them as tools, examine them as documents of history.

A: How did you really get started?

SB: I guess I'm a visualist; people have called me that. That's why I'm in ophthalmology. My original field of study was neurosurgery. But I'm a visual person, and I'm a spatially visual person. In other words, if you had forty odd-sized boxes here and six packing carts, I could tell if it would all fit.

A: I can't do that. I can't look at a room of people and have any idea how many are in the room.

I can take the stuff that other people throw out and make them masterpieces. I have that kind of vision. —SB

Dr. Rodman Operates, 212 Watch, Philadelphia, 1863

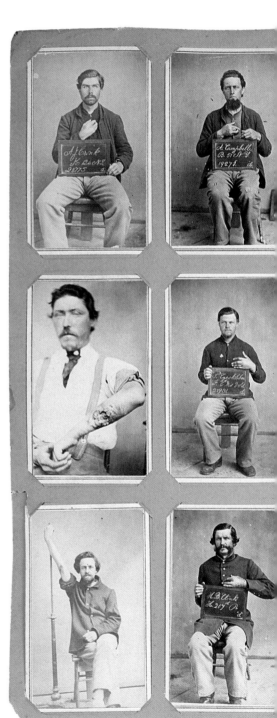

Postmortem of Girl in White Dress, 1845

These *carte de visite* photographs of maimed men displaying their wounds are part of a catalogue of misery carefully assembled by Dr. Reed Brockway Bontecore, surgeon of the Second New York and director of the Harewood Army Hospital in Washington. All of these men were wounded during the last two weeks of the Civil War.

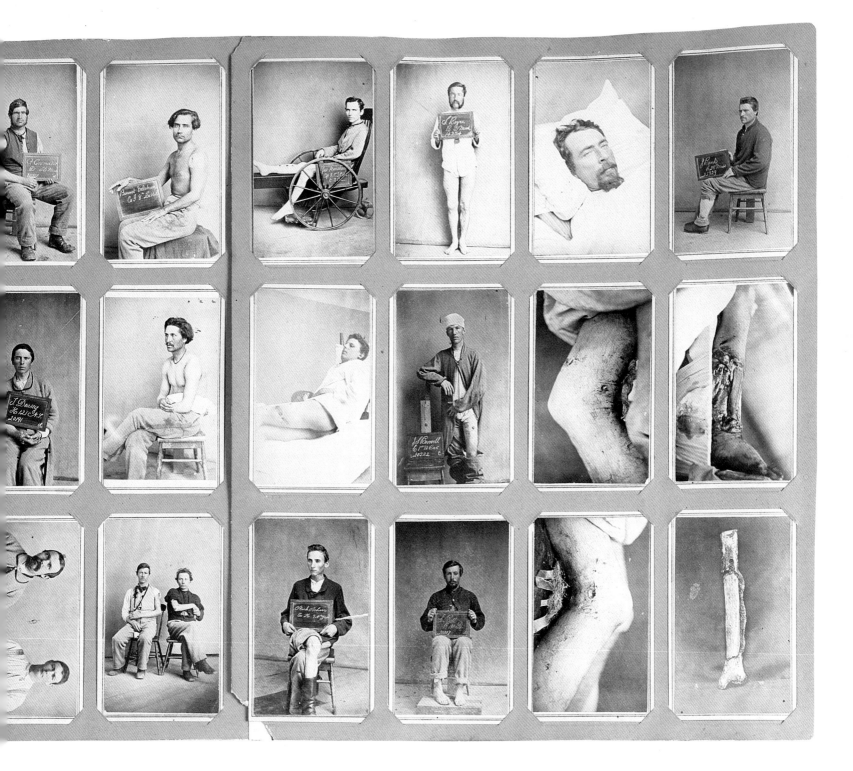

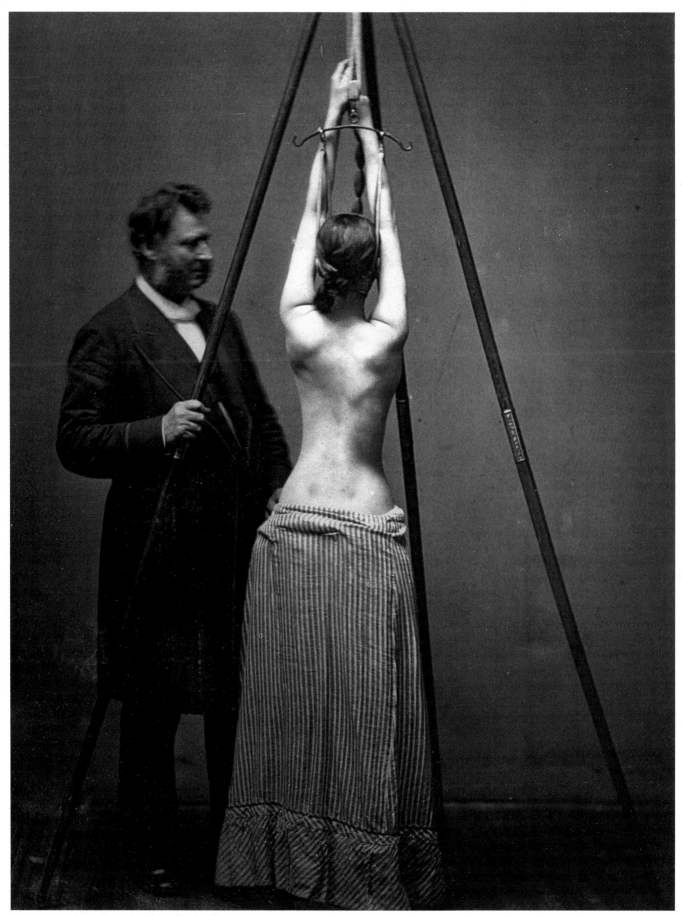

Dr. Sayre and His Patient with Scoliosis, 1877

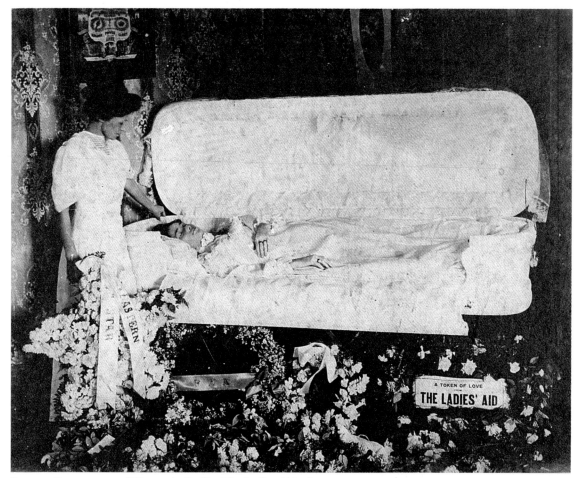

Prayton, *Postmortem of Woman in Coffin, The Ladies Aid*, 1895

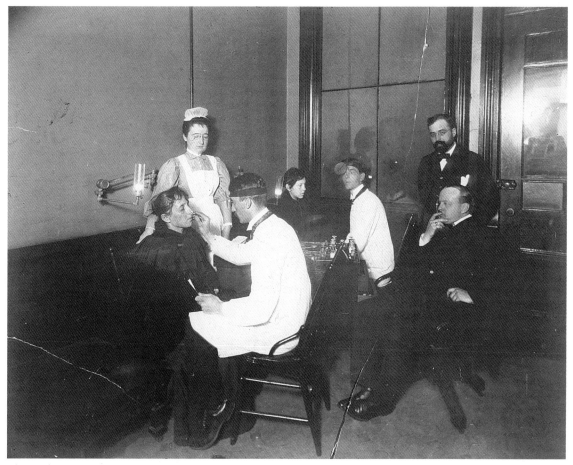

The Professor, Otolaryngology Clinic, Chicago, 1890

Painted Tintype of an Old Lady, 1870

SB: I can't remember your name. But I can tell you how many cartons and what size cartons all these pictures will fit in. I do the same with photographs. I look at photographs and see stories that other people, who are experts and have looked at the same photos, don't see. And even though I am an ophthalmologist and not in the historical field, I am able to recognize things that "experts" are not able to recognize. Then I realized that I had become the expert. My big contribution is to medical photography, being able to collect it and amass the largest collection of early medical photography in the world.

A: How did you come to collect that?

SB: First, it had to do with my recognizing that in the mid 1970s I was in a special time and place, and that if I chose to, I could collect all of the medical photographs that came on the market.

A: Where had you seen them first?

SB: The first medical photograph I saw was a daguerreotype, shown by a friend of mine who was a collector. He showed me a daguerreotype of a South American Indian with a tumor on the jaw. I became interested in daguerreotypes, but I never found another one like it. Why not go out and get lots of those, I thought, they're great. I am different from most other collectors. One of the things I have found is that most are closet collectors, they don't want you to know what they have, how they got it,

when they got it, etc. They won't show it to you, they will tell you about it. And I am the exact opposite. I have had my own medical photo-history journal for eight years, underwritten by Bristol Laboratories. And I can publish and print any photograph that I want to, any of my discoveries. I appreciate the ability to just go out and find images and publish them.

A: Where do you find the photographs? In flea markets?

SB: Every weekend I go to a flea market. My life is dedicated to art and collecting. In Paris I found some great stuff. By walking

I bought a daguerreotype that was so spectacular. I took one look at it and said, "This is not just a daguerreotype, this is the epitome of American art."

in the streets, I found what I consider to be a French national treasure. I cannot believe they sold it to me. It is a collection of dermatologic and tattoo photographs, original photographs from a one-of-a-kind collection done by the head of the French historical society no less, and a dermatologist. They were in this book shop. They had even advertised it in the catalogue, and I came in time and I got it. My friends are amazed by what I do.

More than sixty percent of my week is devoted to my collection, so it's actually costing me a fortune, because I am not practising. I am one of the best surgeons around, but I realized I had to make some decisions. With my skills as a surgeon, I could be helping many more people and making good money. I was told, when I had my first exhibit back in 1977 when photography was just coming of age, that I had a special way of seeing, and that I should spend most of my time doing this. Because I had a way of looking at photographs that other people didn't. I have written five books. How many people have two books come out in a year? What I've put together here is *Early Dental Photography in America*, which is a companion volume to *Early Medical Photography in America*. No one knew that dentists were major photographers, that Samuel Bemis was a dentist, that Alexander Wolcott, who got the first patent for photography in America, was a dentist. Dentists, of course, discovered anesthesia. No one had ever realized that there were two different photographs giving examples of the same operation under anesthesia in 1847. They are so rare, and so infrequently published. I have originals of both.

A: What else are you working on now?

SB: My big project now is *Blue, Grey and Red*.

A: What's that?

SB: It is the history of the Civil War wounded soldier. And I have a terrific co-worker.

A: Who is it?

SB: Walt Whitman.

A: How did you manage to contact him?

SB: Through his books. I have figured out the style of my book, which will be really dynamic. The book itself has to be a

Amputation Scene, Gettysburg Battle Field, 1863

Joiliet Prison, Assistant Warden with Inmates at Rest, 1895

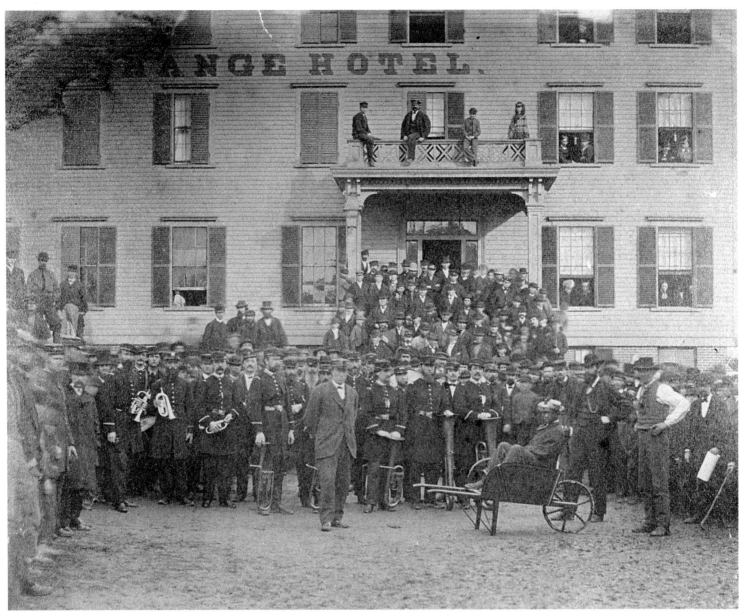

Black Teenager in Wheelbarrow in front of Exchange Hotel with Crowd and Civil War Band, no date

*There is one black man in this picture. What is he doing here?
He's all dressed up. Back then, when you won a bet, they carried you
around town in a wheelbarrow, as the honored guest of the town. Judging
by the band and other figures' dress, this picture is mid Civil War. It must
have had something to do with the Emancipation Proclamation. —SB*

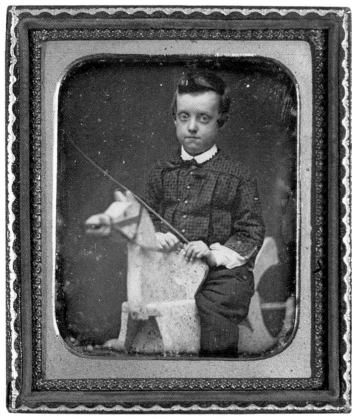

Boy on a Hobby Horse, 1844

J. Gurney, *Black Woman,* 1852

masterpiece. If someone else could do it other than me, I would let them do it. If someone could do a better job, I wouldn't bother. The dental book is a good example. The front of the book is mine, the back is other scholars'. They were doing a book on dentistry and didn't know anything about the early history of dentistry and photography. They didn't know that these photographs existed.

Did you know that Walt Whitman was a Civil War nurse? Did you know that he wrote a book called *Specimen Days,* about his Civil War experiences? His work described my pictures perfectly.

Other people own these images, but there is a problem. They don't see what they're about. A lot of my pictures come from other collectors who don't see what they have. They sell them to me and I tell the story behind the pictures.

A: Are you interested in the idea of a masterpiece?

SB: Definitely, I've even helped create some. Masterpieces are timeless documents that have nothing to do with the history of taste but everything to do with achieving the highest knowledge of ourselves. They're masterpieces in how you see them. What's great about the era we live in now is that we are living amongst masterpieces. It's still such an early time for collecting that

people haven't realized that they are surrounded by masterpieces.

That's about the best way to view my collection. I haven't thought about it as clearly as you have forced me to right now. If you were alive in 1890, but had the knowledge of 1990, you'd go out and buy all the Renoir, Matisse, and other Impressionists you could. That's the way I'm acting. I believe that the pictures I'm buying are masterpieces. We are at a time when you can buy Monet and van Gogh. Remember, van Gogh sold one painting in his lifetime. We can go out and buy masterpieces in photography, especially daguerreotype photography. I recently bought a daguerreotype that was so spectacular. I paid a lot for it, but I took one look at it and said, "This is not just a daguerreotype, this is the epitome of American art." And it was. It was gorgeous, one of the most gorgeous images I have ever seen, and it is probably among the top ten daguerreotypes in America. I just got it four months ago. And that's the way it is. Monet is out there, and people are just walking right by.

What I do, and what my talent is, is to supply words and context for photographs. I can take the stuff that other people throw out and make them masterpieces. I have that kind of vision.

Hunter-Gatherers in the Age of Mechanical Reproduction

By Harry Lunn

Photograph collecting is a custom that has flourished since the earliest days of the medium, the photographic pioneers themselves being amongst the pre-eminent collectors. In England and France during the 1840s and '50s these "amateur" photographers tended to be members of both the intellectual aristocracy and the financial elite. This meant that they usually had both the time and the means to pursue their experiments, and avidly exchanged information on the exciting new phenomenon.

William Henry Fox Talbot, who originated the calotype process in 1939, a process that has become the foundation of the modern photographic technique, was an English aristocrat, inventor, and sometime member of the British Parliament. His country seat of Lacock Abbey, now the site of the Talbot Musuem, was the center of his enterprises, as well as the focus of many of his earliest photographic images.

In France the formation of the Society Française de Photographie (founded 1854) fostered the exchange of images between the French "primitive" photographers in much the same way the Royal Photographic Society (founded 1853) fostered the exchange between photographers in England and their colleagues abroad. The circle of photographers who formed around the influential French photographer and teacher Gustave Le Gray were likewise known to exchange prints among themselves, although most of the resulting collections have now been lost. One that survived, however, had been formed by an unidentified photographer with the initials W.H.G. and appeared miraculously at a routine auction of the contents of a Parisian apartment at the Hôtel Drouot in January, 1990. The intense interest generated by the Drouot professional claque at the sale preview caused the auctioneers to withdraw the lot and organize a separate catalogue sale with ninety-one prints, including eleven images by Le Gray or attributed to him and thirty-eight prints by W.H.G. himself. To this day, W.H.G. has not been identified except by his initials.

Collections by public institutions also began to flourish at the inception of the photographic movement, notably at the Bibliothèque Nationale in Paris, where artists working in media subject to multiple reproduction were required by the state to submit an example of their work, gratis. (The Library of Congress, in Washington, required a similar donation for copyright purposes at this time.) But the official sanction for the new art form came, not surprisingly, from the ruling elite. In England, Prince Albert was fascinated by the medium and interested Queen Victoria in its possibilities. The eminent early English photographer, Roger Fenton, also functioned as something of a court photographer, recording the royal children with real sophistica-tion. The fruits of Prince Albert and Queen Victoria's connoisseurship are now on display at the Royal Archives, Windsor Castle, and key images are on loan to various international exhibitions. One of the most fascinating items in the collection is an album of fifty photographs by Edouard Baldus, documenting the newly constructed rail line from Paris to Boulogne, and presented to the Queen and Prince Albert to commemorate their visit to France in August, 1855. The album was commissioned by James de Rothschild, who organized financing of the railroad construction and later had twenty-five albums made for associates in the industry and public figures of the time. Several of those albums have survived intact and entered the collections

Gustave Le Gray, *The Broken Wave*, 1856–59

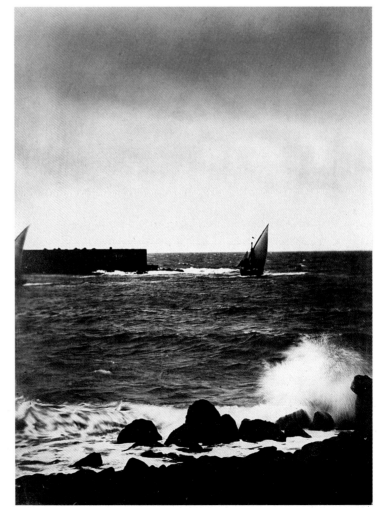

of the Eastman House and the Canadian Center for Architecture.

Although much of his collection was destroyed during the Commune, when the Chateau of St. Cloud was torched, Napoleon III was an enthusiastic collector who commissioned Le Gray to make a photographic record of the celebrated military manuevers at the Camp de Chalons in 1857. Fortunately several contemporaneous albums of the manuevers have survived as striking evocations of the Third Empire, and other material from his collection has been preserved at the BN and the Museum of Compiègne. In early 1978 a Parisian dealer showed me an album that obviously had been part of the Emperor's collection and had been found that morning on the ground at the flea market at Montreuil. The album's regal contemporary binding with an elaborate dedication to Napoleon III embossed on the cover was immediately recognizable to me as a twin of the I.L. Lilley album (late 1850s) on Napoleon's retreat in exile on St. Helena, which had figured as the cover of a catalogue for an exhibition on early photography that I had assisted in organizing at Colnaghi's in London in late 1976. I immediately acquired the album, and then offered it to the BN, which gladly added it to the national patrimony.

The English benefactor Chauncy Hare Townsend (1798–1868) was perhaps the first major private collector of importance, outside official or photographic circles. A wealthy aristocrat, Townsend was an ecclectic collector most notable for his connoisseurship of early photography. His collections were bequeathed to the South Kensington Museum, which evolved into the Victoria & Albert Museum in 1899. In the 1970s, the photographs acquired by Townsend were rediscovered by Mark Haworth-Booth, curator of photographs at the V & A. Perhaps the most extraordinary image in the collection is the "River Scene—France," by Camille Silvy, taken in 1858 and exhibited in London the following year. Townsend also acquired a series of seascapes by Gustave Le Gray, which remain magnificently preserved.

The role of massive international exhibitions in unveiling photography for a larger public cannot be underestimated. The Crystal Palace Exhibition of 1851, masterminded by Prince Albert, gave an

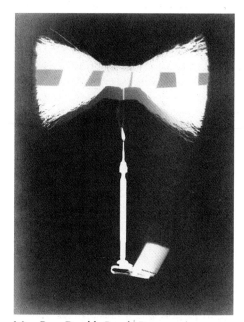

Man Ray, *Double Brush*, Rayograph, 1922

HOT PIX: Current trends in the medium have had less to do with pure photography than with the use of photographic technique in the service of the largest artistic ambitions. Long before this sort of work had become fashionable, the impish *genie* of 1920s avant-gardism, Man Ray, had launched the movement with his Rayographs, darkroom generated images on photographic paper. This Rayograph sold at Christie's, New York, in 1990 for a record $132,000. —HL

important place to photography, and helped inspire some of its first documentary records, both in the way of paper images (Philip Delamotte) and in the way of stereoscopic plates (Negretti and Zambra). In Paris, the two international exhibitions of 1855 and 1859 included work by the major French artists of the day, and subsequent official exhibitions introduced the work of landscape photographers of the American West, notably Carleton E. Watkins.

The role of photographically illustrated books in fostering interest in the medium for the general public is likewise highly important. Bibliophiles who collected widely in France, England, and the United States in the latter half of the nineteenth century often added expensive volumes illustrated with original photographs to their collections. For example, in December, 1990, the library of a celebrated French collector was sold at auction in Paris. The most expensive item in the sale, also a world-record price for an album of photographs, was a rare

compendium of calotypes from 1852 of Egypt and Nubia by Felix Teynard—the only photographic item in a sale that included a fourteenth-century Book of Hours, rare manuscripts of Baudelaire, and a wealth of modern French classics. The finest example of the 160-plate album known, the Teynard had probably been acquired soon after its publication in 1857 and then languished unopened for generations until it was sold last year.

The tradition of the illustrated book took root early in the history of the photographic movement throughout Europe: in England, Talbot's *Pencil of Nature* appeared in 1844, and in France, the first Blanquart-Evrard editions were published in 1851. Not until the 1860s and 1870s did the tradition transfer to the United States, primarily owing to the Civil War, which was to be the catalyst for two major American albums: *Gardner's Photographic Sketch Book of the War* (1866), including one hundred separately mounted albumen prints bound in two volumes; and *Photographic Views of the Sherman Campaign* (1866), with sixty-one albumen prints by George N. Barnard recording the aftermath of General Sherman's scorched-earth campaign in the South.

Later, the fascination with Western exploration inspired several projects, including the Wheeler Survey of the early 1870s, with photographs by Timothy O'Sullivan and William Bell, and the Yellowstone album of William Henry Jackson, presented to members of the U.S. Congress in 1872 and regarded as instrumental in the designation of Yellowstone as a national park that same year. The Jackson album represents one of the first instances of photography's impact on political life, a commentary which took on new dimensions a hundred years later with the Mapplethorpe affair.

The nineteenth-century interest in presentation albums—instant collections in themselves—created both a popular form of entertainment and a more refined appreciation of the medium. On the popular level were the "livres de voyages," or "around the world albums," in which the privileged of the mid-to-late Victorian era documented their travels by creating personal albums of reminiscences. For the most part such records appear rather banal, both in the vision of the tourist and that of the photographer. While "liv-

res de voyages" had lost most of their popularity by the early 1900s, there have been some extraordinary examples of the genre that have survived. One notable example is an album that surfaced in provincial France in the early 1970s with five beautiful landscapes of the American West by Watkins taken during what appears to have been a year-long Westward swing through China and Japan.

Finally, one must acknowledge the personal collections of the nineteenth century created by a handful of truly talented artists. Julia Margaret Cameron, for instance, assembled at least four major albums that have survived. One, dedicated to Sir John Herschel, was acquired at auction in London by the legendary American collector Sam Wagstaff—only to be relinquished by him to the National Portrait Gallery in London, which had attempted to block the album's exportation. Another Cameron dedication album was acquired at Sotheby's, London by an American collector. It was then featured at a Sotheby's auction in New York and acquired by Daniel Wolf, only to become the decisive factor in the Getty

Andres Serrano, *Klansman, (Knight Hawk of Georgia IV),* 1990

HOT PIX: Serrano's image *Piss Christ* helped launch the NEA/Mapplethorpe ruckus in 1989. Serrano's recent series of "nomads," documenting New York's homeless, and the Klan series (illustrated) will offend only those indifferent to contemporary social reality.—HL

Museum's move to create a photography collection in 1984. It is precisely this "recycling" of collections that has added great energy to the collecting surge since 1970.

In the early years of photography the scene in America did not involve major individual collectors to the extent it did in France and England. Not, that is, until the arrival of Alfred Stieglitz, considered the dominant figure in American photography of the first third of the twentieth century. From his editorship of "Camera Notes" (1897–1902), and "Camera Work" (1903–1917), his stewardship of a series of New York galleries from 1905 to 1946, and his own creative work from the 1890s onward, Stieglitz fostered the collection of photography by both private clients and public institutions. His influence was so great, in fact, that when Stieglitz demanded in 1933 that either the Metropolitan Musuem of Art receive his personal collection of prints by colleagues in the Photo-Secession or he would destroy them, the Museum dispatched a truck to rescue the priceless horde. Today, Stieglitz's legacy forms the core of the Musuem's early-twentieth-century collection.

The mid 1930s saw several important developments at the institutional level, with the creation of the Photography Department at the Musuem of Modern Art in 1936, and the seminal catalogue created by Beaumont Newhall commemorating the hundredth anniversary of the invention of photography. *The History of Photography,* expanded and revised five times since initial publication, is the definitive history of the medium. As director of the George Eastman House, Newhall secured a series of acquisition coups for that institution. In 1947 Newhall visited the eccentric Chicago perfume manufacturer Alden Scott Boyer to review his holdings of more than two hundred Southworth and Hawes daguerreotypes. To his astonishment, Newhall discovered that Boyer possessed 750 Hill and Adamson calotypes, along with a wealth of other treasures, stored in the vaults of a former bank which Boyer had acquired to house his massive collection. In 1950, following the death of his wife, and with no other heirs, Boyer presented the collection to the Eastman House.

In the mid 1950s, the important Parisian rare-book dealer, André Jammes,

and his wife, Marie-Thérèse, became interested in nineteenth-century photography. They organized the first important postwar auction of photography in Europe in 1961. In 1969, they also assisted in the landmark exhibition of French Primitive Photography at the Philadelphia Museum of Art (with a catalogue published by *Aperture*). Today the Jammes collection is considered the most important assemblage of rare nineteenth-century French photography in existence. Choice selections were exhibited at the Chicago Art Institute in 1977 and '78, and the accompanying catalogue has since introduced the collection to a much wider audience.

The closing of the last Stieglitz gallery in 1946 signaled a stagnation in gallery exhibitions in America until Helen Gee opened Limelight in 1954. The intimate gallery and coffeehouse offered a series of temporary exhibitions, usually one-person shows, that continued until 1961. In the course of these seven years, nearly every important twentieth-century photographer was exhibited. Few collectors seemed interested in acquiring these images though, despite prices that appear absurdly low today—$25 for an Edward Weston image, $100 for a Moholy-Nagy. (By contrast, in 1990 a Japanese musuem paid $1 million for a collection of thirty-five Moholy-Nagy images).

Starting with the opening of the Witkin Gallery in 1969, the 1970s saw a frenzy of interest in collecting, serviced by a rapidly expanding network of art galleries, auction houses, and museum exhibitions. It was during this period that some of the great collections of the postwar era were formed, further supporting the contemporary collecting fervor that has continued through the 1980s and into the 1990s. This expansion in the photographic market, however, was by and large confined to America, with the exception of key collectors in Europe. In recent years the collecting base beyond the States has included England, France, Switzerland, Germany, and Japan.

One of the first of the generation of collectors that became active in the 1970s was the Zurich art dealer, Bruno Bischofsberger, who sold his holdings to the Getty Museum in 1984. Another was the English art dealer, Howard Ricketts, who had a fine collection of early English photography, much of which is now with

the Musuem of Photography at Bradford.

The most extraordinary story of a private collection that led to the creation of a major art institution involves the Canadian architect Phyllis Lambert. In May 1989, Lambert created the Canadian Center for Architecture in Montreal to organize and exhibit her collection of books, drawings, and photographs relating to architecture. This institution has the finest collection of architectural photographs extant, and is especially rich in nineteenth-century material.

The Gilman Paper Company in New York houses some of the finest individual nineteenth- and twentieth-century photographs to have been on the market in the last fifteen years. Among their important collections is a rare album of Maxime DuCamp's early photographs of the Middle East (published in 1852), once owned by French architect Viollet-le-Duc, and including an additional group of previously unpublished proof prints from the series.

The Gilman Collection is also responsible for publication of the most sumptuous volume on photography of this century, comparable to the finest presentation albums of the nineteenth century. Published in 1985 with text by Pierre Apraxine and extraordinary reproduction plates by Richard Benson, the two hundred images span the history of photography from the frontispiece by Talbot to the final plate by Diane Arbus.

The most dramatic collecting coup in the last fifteen years was managed by the Getty Museum in 1984, in an acquisition that involved a number of private collections including those of Sam Wagstaff, Arnold Crane, and, as noted earlier, Bruno Bischofsberger. The Jammes sold an important group of French prints in this same transaction, which was handled with great skill and secrecy by the New York dealer, Daniel Wolf. In terms of the importance of the collections and the sums involved, the Getty acquisition represents the largest single sale of photography in history.

A successful collector once told me, "Dealers who collect personally lose their best clients." Despite this admonition, it must be said that dealers do often prove to be notable collectors. The trend toward private collections leading to books and exhibitions has accelerated in recent years. The private dealer Stephen

White, of Los Angeles, arranged an exhibition and catalogue of his collection that opened at the New Orleans Museum and travelled to a number of institutions in the United States and Europe. This led to the sale of his collection to a Japanese museum in 1990.

Another significant example of this type of collaboration came out of an exhibition at the Kunsthaus in Zurich in 1990, and involved the print collection of the German collector, Werner Bokelberg, which was accompanied by a stunning limited-edition catalogue of his own design. Another German collector, Manfred Heiting, currently is working on a book project defining his extensive and eclectic holdings, which are far richer in examples from the last twenty years than others discussed here.

One of the most notable recent collaborations between a museum, a collector, and a corporate sponsor involved the acquisition of the John Waddell collection by the Metropolitan Museum of Art in 1987. This extraordinary assemblage of images from the richly creative period between the two world wars was acquired by gift from Waddell and a donation by the Ford Motor Company, which also underwrote the exhibition and catalogue.

The Paul Strand exhibition, which opened at the National Gallery of Art in Washington in December 1990 and will travel widely in the United States and abroad, was greatly assisted by the Southwestern Bell Corporation, which has donated sixty-one of the 150 Strand prints displayed in the exhibition. The Strand project is evidence of the Gallery's commitment to a new program involving the acquisition and exhibition of photography, building on Georgia O'Keefe's gift to the musuem in 1946 of the master set of Stieglitz prints.

Since the mid 1970s auction houses in New York and London, and more recently in Paris, have played an ever larger role in spurring on the collection of photography. The first major photographic sale of the postwar era occured at the Swann Galleries in New York in 1952, a sale that involved the dispersal of the Albert E. Marshall collection, which aggregated $5,300 for the 371 lots sold, with Talbot's *Pencil of Nature* going for $200. In April 1991 the Swann sale totaled $390,000 (against $2,080,000 at Sotheby's and

McDermott & McGough, *God's Mercy*, 1919, 1990.

HOT PIX: McDermott and McGough represent the late-1980s and early '90s concern with historical and technical audacity, moving from canvas to antiquated cameras to explore an evolving vocabulary bound into a Victorian/Edwardian style. The verdict will not be in for another twenty years, but I intend to hoard whatever I can in the meantime. As of May 1990, the photographs in editions of three go for $5,500.—HL

$1,500,000 at Christie's the same month), and the last known price for a *Pencil* was $150,000.

All this has been achieved through a relatively small group of collectors. Auction houses distribute no more than three thousand catalogues each per sale (as a rough comparison, just consider that there are an estimated twenty million collectors of postage stamps in the United States), and the dealer base is equally small. There are now eighty-six members of the Association of International Photography Art Dealers, Inc., the dealer trade group which includes art galleries with a photographic department as well as those dealers who trade only in photographs.

While the collector base is growing slowly, buffeted by the same political and economic conditions as the art market of which it forms a segment, there is a stable contingent of individuals and institutions whose interest in rare photography is genuine and growing, and it would appear that the trend will continue through the 1990s.

The Collection of
Dorothy Norman

Alfred Stieglitz, *Dorothy Norman*, 1931

*All these works have a delicacy and
a feeling about them. These artists
bestow their affirmation upon everything
they touch or paint, and I love that.* —DN

Aperture: Do you consider yourself a collector?
Dorothy Norman: No.
A: Then how do you happen to have all this wonderful artwork?
DN: The first thing I ever saw that I wanted was a Stieglitz print. This happened when I first met him. I had never bought anything, and I had very little money. I walked into Stieglitz's gallery . . . I didn't know who he was, didn't know his name, I didn't know he was a photographer. I knew nothing about him.
A: Why did you go there?
DN: Just to see the art. I saw his prints, and didn't know that they were great photographs. And I didn't think about photography as an art, but his prints moved me. But I couldn't buy them at first. Finally, I bought one. Then I bought paintings by

John Marin when I could — Stieglitz showed him too. I love all of them. I was really trying to help the artists and help what Stieglitz was doing.
A: How did you get to know them?
DN: I was invited to a party and [Gaston] LaChaise and Marin were there. . . . I became friends with them.
A: What did it cost then? What were the prices of the photographs, do you remember?
DN: Stieglitz gave me a lot of them. He kept feeding me prints. So I just couldn't buy them. All of them, really, in this room, he gave me. Which was wonderful. I thought his work was marvelous, I still do. Everything I have, I love. But at that time nobody else around me seemed to think anything about any of the art I loved. Certainly not my family.
A: In many ways you have a collection by circumstance. Did Stieglitz have any philosophy about collecting, or was that something that you never discussed?
DN: He never thought of collecting. He helped art, he helped artists—but I know he never thought of collecting, never. I tried to think in the same manner . . . Morris Graves, for example. I loved his work, and he needed help. I bought his work early and it was not expensive, although later it became too expensive for me to buy. And my husband, Edward, didn't really love art the way I did, and so I got no help. In 1928, just about the time that I was beginning to feel that Stieglitz was so wonderful, I met Coomaraswamy, who felt the way I did. He said that Stieglitz was the most important artist in this country; this was in 1928 from an Indian traditionalist. He said that Stieglitz used symbols the right way. I didn't know what he meant, but I thought so too. I became interested in Indian art long before I went to India in 1950. But I could only buy that little Vishnu, which I got in London. As for American art, Stieglitz, Marin, and Graves were the ones I really loved.
A: What is your connection with Marin?
DN: I liked his work before I met him, I liked it at once. I didn't know who Stieglitz was or Marin or any of them.
A: Tell me about Graves.
DN: I knew him quite well. I think he is a marvelous painter. I love the brush strokes.
A: Do you see a connection between the two of them?
DN: I can see, as we talk, how they are deeply related. That little tree of Marin's has a feeling of a Graves, although it's different. I suppose the beautiful sense of tones . . .
A: When you first met them, were artists like Stieglitz, Marin, and Graves getting support from anybody? Did Stieglitz do well, in the sense that people were buying?
DN: Marin sold better than the rest. He was considered the best artist by the critics. And there was a poll. I forget what year, but in the late 1940s. All the art critics in America voted Marin the best artist in the country. But Stieglitz really changed the whole culture of this country by what he did at 291. He introduced Picasso, Rodin, and Matisse and Brancusi and all the wonderful

Dorothy Norman's New York home

and important artists from Europe at a time when nobody was interested in them.

A: How did he see them—had he been to Paris?

DN: He had been to Paris, but that isn't what did it. Steichen brought over a lot of things from Europe and Stieglitz either showed them or didn't. And then he also showed African art early.

A: So he had an extraordinary eye.

DN: Yes, and heart.

A: He was helping these artists by introducing them to this country, and in so doing changed everything here.

DN: It did. It opened people's eyes to what was really happening,

and what was wonderful. But the European painters didn't mean the same thing to me that Marin did, and the work doesn't touch me the way Marin's does.

A: Do all of Marin's works move you, from the paintings and watercolors done in Maine, to the New York images? Oh, and the Marin you have in your home, the Stonington church. That's fantastic.

DN: I got that from a box of Stieglitz's—nobody else had bought it. I was allowed to go through the boxes and I bought that one. I loved the churches of America, the New England churches. I love all his [Marin's] work, which is why I have surrounded myself with it.

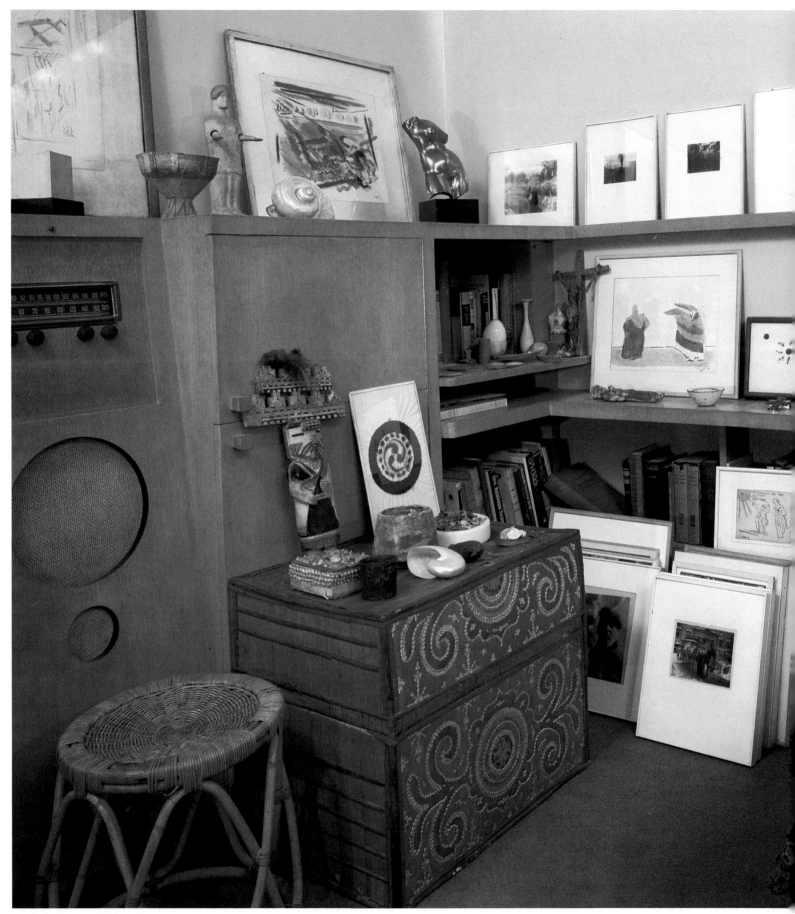

Dorothy Norman's New York home

Alfred Stieglitz, *Equivalent, Music No. 8, Lake George*, 1924

*[Stieglitz] never thought of collecting.
He helped art, he helped artists—
but I know he never thought of collecting.*

A: Do you look at the Marins and the Graves and Stieglitz works and feel differently about them now? Are you seeing things in them that you didn't see before?

DN: I am always seeing new things. The initial feeling is still there, and the feeling of today is there as well.

A: So they keep their "presentness."

DN: They do. All these things are just as immediate as they were when I first saw them; they are so elemental. I love them.

A: You've mentioned the affirming quality of this work. Do you think the times were very different then, so that people could find a more positive view of the world, or do you think that there are always artists who find that view?

DN: I think it's the artists, not the times. When I started becoming interested in art, the times were not so good. I had

found a few people who had the same feeling about life, who went to the Barnes Foundation, in Philadelphia. I was a student. I first saw African art, I first saw everything there. Matisse was there and Renoir. . . . There were no reproductions then. I had been in Paris and I hadn't seen them. I was with my parents, traveling and going to museums and seeing everything except modern art — it wasn't exhibited, or very little, and my parents didn't know about it. We just went the way you were supposed to; we saw everything and nothing. That was in 1923.

A: Do you think photographs and paintings have different values?

DN: No.

A: Do you think there is any difference, intrinsically?

DN: I suppose, in a way.

A: How so?

DN: One is traditionally done by hand. . . . I understand the world's approach to art as different from photography, but I don't feel it.

A: What photographers matter to you most?

DN: Stieglitz and Strand.

A: Why does Strand move you?

DN: Because he had such a wonderful eye—especially in the beginning. I don't like the later Communist things. I think they're interesting, but not wonderful. I like Sudek. But I am not moved by him. I like Ansel Adams; I like Eliot Porter, some of his works move me. I don't think he's great, but he's awfully good. By the way—on the subject of painting versus photography, I just think about the artists, not about the medium.

A: And what about your own photography? Has it been influenced by Stieglitz?

DN: I suppose it has. When I am in New England I am so aware of the gravestones and the churches and all the things on Cape Cod. When I'm in New York I am moved by certain skyscrapers, and I suppose I was lucky to be able to have Stieglitz looking at my prints and encouraging me as I made them, although I never tried to imitate him. But I suppose he, especially, influenced me inside.

A: In terms of your openness to what was going on around you?

DN: Right.

A: What about music and dance from earlier this century?

DN: I love Stravinsky and I love Balanchine.

A: In many ways it's a kind of innovative quality you're looking for in the work that you accumulate and in the people you admire.

DN: Yes, and as I started to talk about before, a certain kind of attitude toward the world, toward life. All these works have a delicacy and a feeling about them. There is nothing crass or ugly. It doesn't mean that there isn't ugliness in the world, but these artists seem to me to have a wonderful feeling about everything; they don't make reality, but they bestow their affirmation upon everything they touch or paint, and I love that.

Dorothy Norman's New York home

The Collection of
Thomas Walther

Thomas Walther: This is going to be sort of a staccato brainstorming. Just some ideas that came to my mind when I thought about my apparent need to collect all these beautiful objects. There's certainly something like passion involved, a willingness to sacrifice almost everything else to the desire to enlarge and enhance the collection, to add elements and further this rather complex notion of a mosaic. Discrimination, in terms of quality, is an important issue, aiming at finding the essential images that almost reflect an inner state of mind in their constellation of the elements of reality, transformed by some spirit of abstraction. In many cases, this is a vision of simplicity, beauty, balance, harmony, and perfection. Striving for essence is probably at the core of this pursuit.

Aperture: What do you think that essence is about?

Florence Henri, *Thomas Walther at Ten Years Old*

*There's certainly something like passion
involved, a willingness to sacrifice
almost everything else to the desire to
enlarge and enhance the collection.* —TW

TW: It's a core issue, sort of an internal structure. Perhaps it is a manifestation of the creative spirit as an inherent kind of quality. Sometimes there is almost a divine pattern to be found in the most unlikely or seemingly chaotic constellation of elements. You look at the most banal kind of image at first and then you see that there's a dormant pattern involved. Greatness is not always apparent at first. It needs to be discovered.

A: It's more subtle?

TW: It's definitely more subtle. I think that a collection quite naturally reflects the persona of the collector. It's sort of a mirror. It very much reflects the inner structure of the mind and soul of the person. In a way, images might be transformations or sublimations. As objects and collectibles they might replace the lost object of desire. I think that's an important notion. I always wondered why I felt a stronger urge to collect than to create something myself. Why not forgo the accumulation of things, and do something more original? It took me quite a while before I really was convinced that what I was doing out of inner necessity was truly a meaningful pursuit, that creating this multifaceted collection was perhaps important.

A: So now there are all these different ways of expressing yourself, in a sense.

TW: Yes. As I said, they are little splinters of this mirror that has so many facets, and they are an expansion of my vision. They are a way to reach out into the world and to discover and understand in a sort of step-by-step approach. I was always overwhelmed by the tremendous variety of reality, in a way. Visually, things surrounding me were always a bit disquieting, so I used my own camera to create moments of tranquility, to arrest motion and emotion, to separate and to distinguish my sense of being from the swirling and rather chaotic elements around me.

A: What about the photograph as something tangible—its physical essence, so to speak?

TW: Clearly the preoccupation with photographs as tangible objects is very important to me. Paper, surface, ways of mounting, displaying, and signing pictures had their own value in the early decades of this century. That's why the notion of vintage prints is so important today, as a documentation of a now-extinct and obsolete approach to artisanry. I love to incorporate certain images into the collection, but they have got to be vintage prints. This way they are tangible manifestations of the artist's initial conception.

A: How do you go about shaping your collection?

TW: Generally I tend to respond to things visually, on a nonverbal, more cerebral level. Only after acquiring photographs can I determine in which way they ultimately might fit in with the other images. The collection originally started as a fairly disparate conglomeration of images, which hopefully in the end will form a

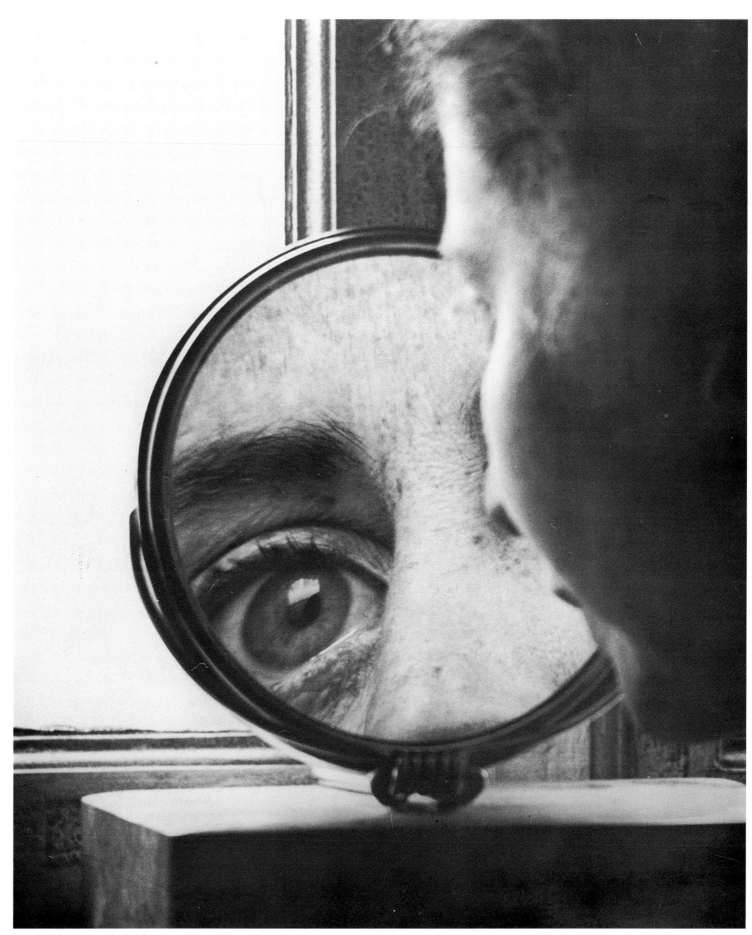

Raoul Hausmann, *Untitled*, 1930

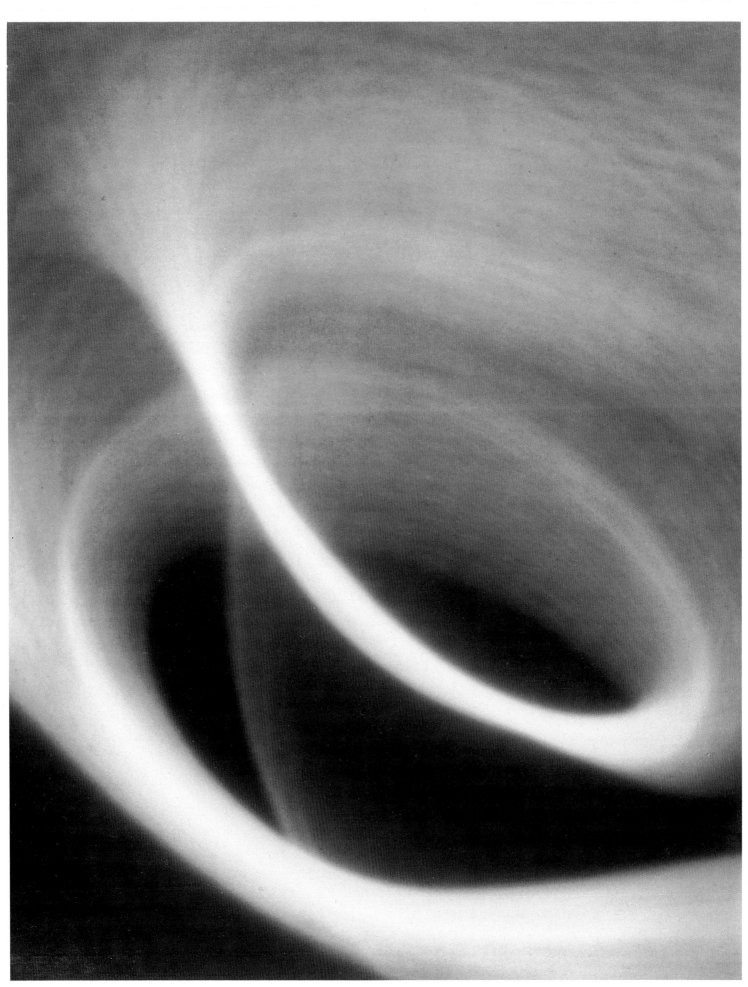

Edward Quigley, *Vortex*, 1932

Gertrud Arnt, *An den Meisterhäusern* (Up against the Master Houses), 1930

Hans Richter, *Filmstudy*, 1926

kind of logical assemblage. It's certainly been a fairly eclectic process so far. It's a kind of dialectic structure that's been formed by these different aspects and approaches.

A: And the images that you collect, they're playing off each other?

TW: Yes, I would hope so, in order to create more momentum and surprise.

A: They lend to each other . . .

TW: Exactly. I mean the way we can play with images, how certain juxtapositions take away strength while others greatly increase the visual message. The period which has attracted me the most is certainly a time when economics and politics were in a state of paralysis, but artists were overcompensating for this, with a sort of explosion of the mind. There was this tremendous urge for new discoveries and the breaking of boundaries in every imaginable way.

A: After World War I?

TW: Yes. That is the time when the Dadaists were appearing on the scene in all kinds of places all at once, like mushrooms.

A: I love that idea; suddenly they're in Zurich and Berlin . . .

TW: In Cologne and Hannover. And they excitedly reacted and adapted to the challenges offered by all kinds of new technologies as well as materials and aesthetic theories.

A: Can you comment on some of your photographs—and how you came to collect them?

TW: A major concern always was economy of expression, simplicity and clarity, rather than intricacy of detail or story values. It's

Man Ray, *Dos Blanc*, 1926

André Kertész, *My Friend G. Beathies*, 1925

not so much narrative that's important to me, it is more singular icons that serve as sort of pillars for the overall picture that matter. And I often feel that one picture can tell a whole story, anyhow. I think certain images can tell more than a whole bunch of mediocre images. Again, what I'm talking about is essence. Perhaps the attempt to interpret life in a literary sense is behind my pursuit; these pictures are an affirmation of life through the more or less unusual grasp of the moment.

A: That's also the idea of essence, in a way.

TW: Yes. Above all, true photography is not representational. There's almost always an element of abstraction involved in the most basic sense. It's about extracting the essence of a quality of emotion caught in its prime inspiration. The image as a frozen, distilled moment. The image always equals a search for the thing itself, which always shines through in great art, be it ancient, primitive, classical, or contemporary. What I try to do or find is a

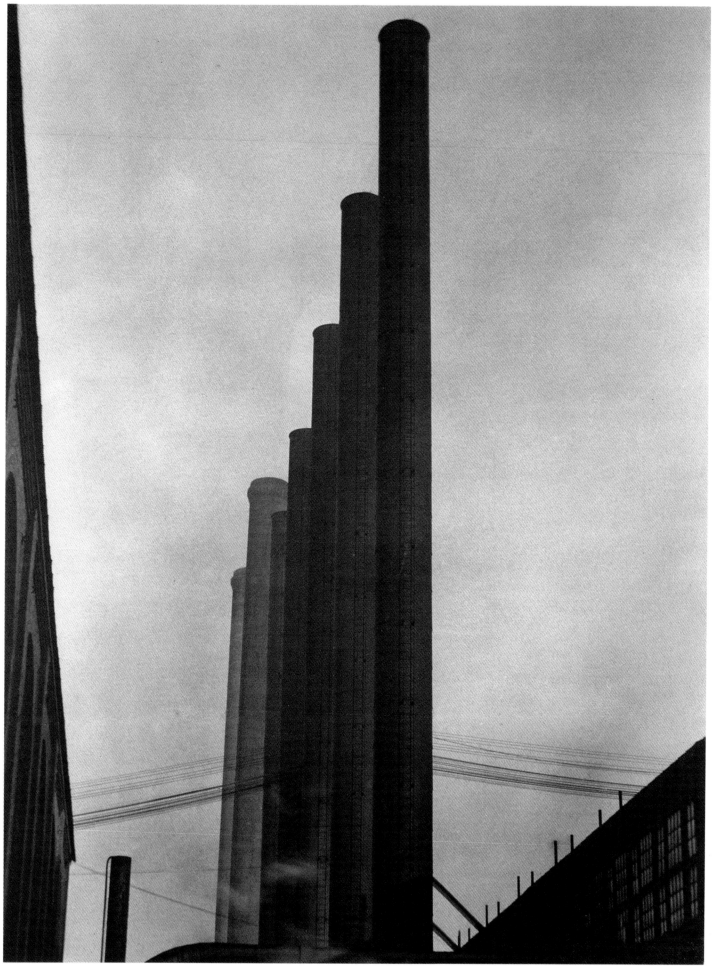

Edward Weston, *Armco Steel, Ohio*, 1922

Paul Outerbridge, *Piano*, 1926

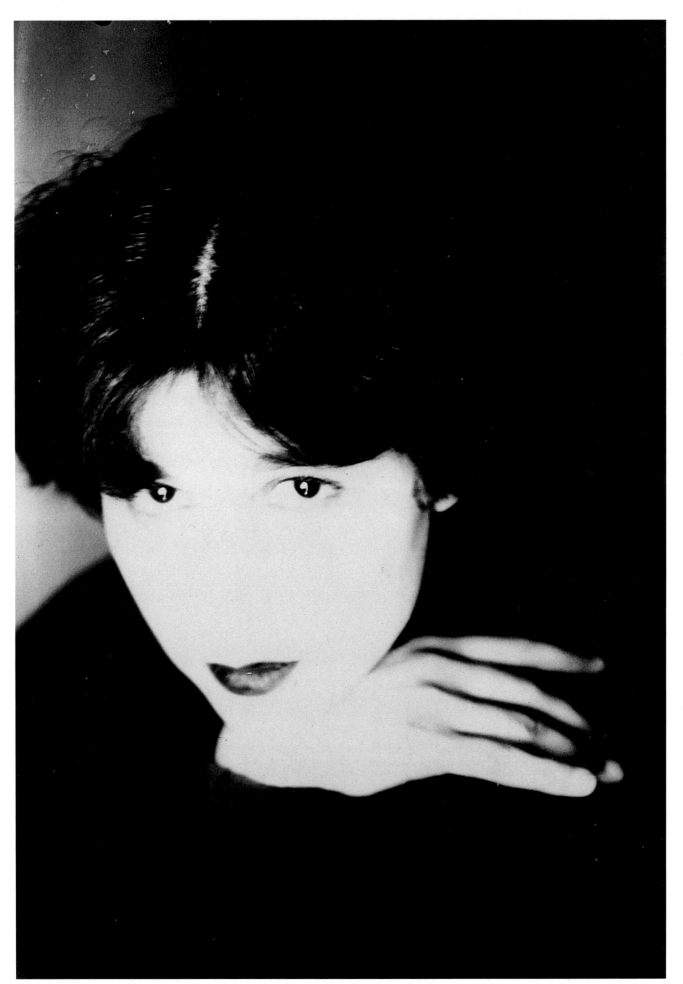

UMBO, *Ruth Landshoff*, 1926

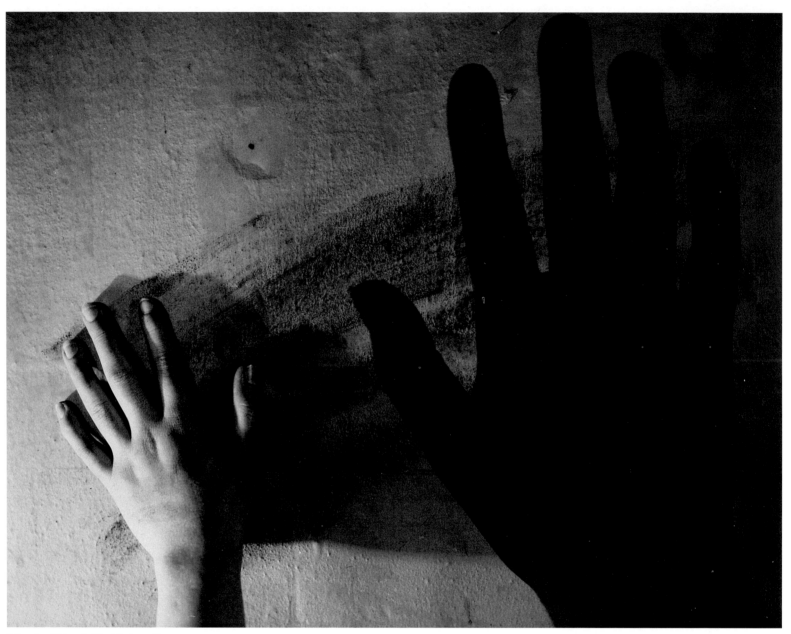

Maurice Tabard, *Untitled*, 1928

picture where the message is stripped to its stark rudiment, its integrated vision. It took almost ten years of collecting to develop this ability, which I think I now have, to discern a mediocre image from the kind of image that just knocks your socks off. It very much has to do with, and is enriched by, the experience of life. So when I was twenty, I would not have had this ability, I think.

A: So it takes time and experience to refine that ability?

TW: It takes life experience, and I think it also takes a compassionate heart, which only develops over time. I think the heart factor is important, too. That's another thing you don't want to write.

A: Yes, I do.

TW: Life does not have to be interpreted by photography. Photography simply narrates, in my opinion, so many aspects of life.

A: It goes back to what you were saying before about not representing life.

TW: Exactly. The record of life, of history, and culture is represented in the arts. And what artistic medium is more equipped and better suited to record our time than photography? It doesn't create change, necessarily, but it certainly registers it in the most immediate fashion.

A: Are you an aggressive collector?

TW: Times used to be much more quiet. Now, it's more of a big-business type of situation. I would hope that I have the right dose of boldness and method incorporated into my pursuit. As a collector, you acquire this scanning technique—the rapid approach. You walk into a room, sometimes, zero in and say, "That's the one!"

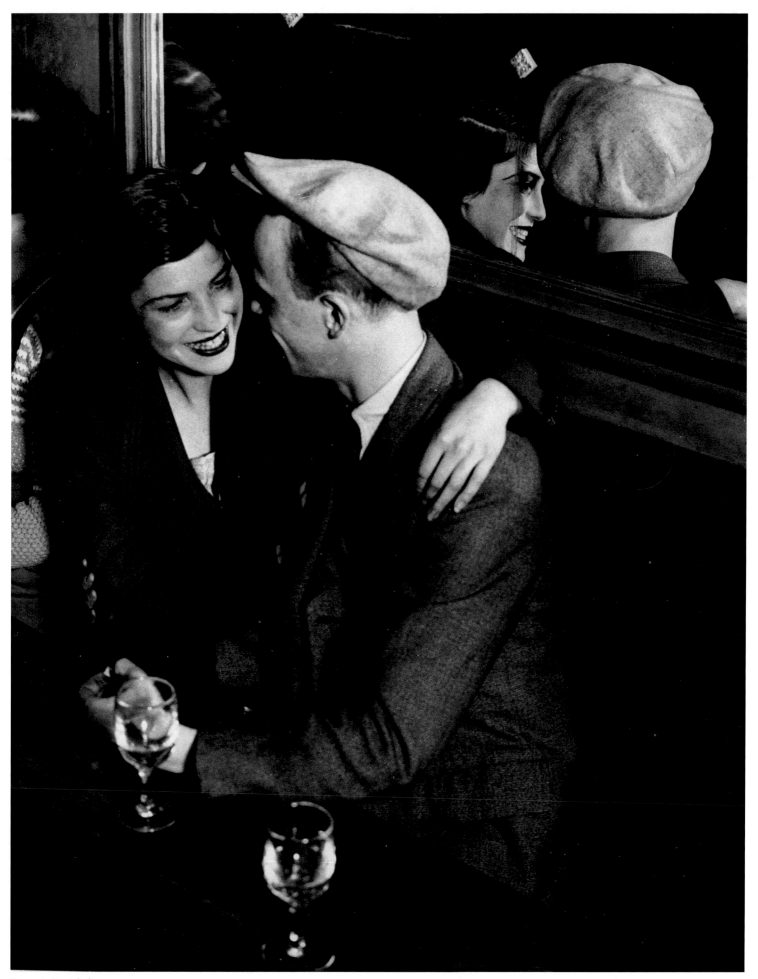

Brassaï, *Untitled*, 1932

High Times and Misdemeanors

By Peter C. Jones

Fine-art painters said photography wasn't art. Fine-art dealers said photography couldn't last. Fine-art collectors said a photograph wasn't worth a thousand dollars. They were all wrong. From early French photographs to the Starn Twins, photography now dominates the art scene. The medium's supporters, who have ridden the roller-coaster ride of the 1970s market boom, the market collapse of the early '80s, and record prices in the '90s, view the current art-world malaise with amusement. They have been there before, have undeviating confidence in the medium, and are prepared to weather the storm.

Black Monday. A dark moment for the opening of the first exhibition of Josef Breitenbach's work from the 1920s and '30s at Chicago's Edwynn Houk Gallery. "We were introducing work that really deserved a market at theoretically the worst possible time," says Houk, "but despite predictions of doom and gloom, the exhibition was very successful." With speculators scrambling for cash, the primary buyers were private collectors who had become passionate about the medium in college. Now prosperous professionals, they are pursuing a twenty-year dream of owning fine photographs.

Last April, demonstrating great faith in photography, Edwynn Houk opened a new gallery just down the street from the Metropolitan Museum of Art in New York with dealer Barry Friedman, who specializes in 1920s and '30s design. From their combined inventory the Houk Friedman Gallery has mounted a stream of museum-quality exhibitions of vintage work in its public gallery on Madison Avenue, while Houk and Friedman have discreetly courted collectors and curators in the magnificent private gallery hidden in the rear.

"Passionate collectors are almost impervious to hype," says Houk. Today's collectors are much more selective than those of the past two decades and acquisition prices are comparatively steep. "Anyone with a high level of connoisseurship is usually getting things that are prized by the experts," says Houk, "but

that doesn't mean that every print is a world-record price." Even at the high end, he says, "real sanity generally prevails."

Sanity in today's photography market can mean $190,000 for a Weston from Scott Nichols; $180,000 for a Strand from Kaspar Fleischmann; $165,000 for a Modotti at Sotheby's $160,000 for an Outerbridge from G. Ray Hawkins; and $150,000 for a Rayograph from Peter MacGill. The dealers are buying as well. Edwynn Houk paid $135,000 for a variant of the "Satiric Dancer" by André Kertész, while Hans Krauss, Harry Lunn, Robert Hershkowitz and Margaret Weston, known as the "gang of four," paid just under $800,000 at the Paris auction house Laurin Gillioux Buffetaud Tailleur

HOT PIX: In 1987 Sally Mann made definitive portraits of her son Emmett at age seven and daughter Jessie at five, both of which have been sought after by collectors. "Virginia at Five" is probably her definitive portrait of her youngest child.—PCJ

Sally Mann, *Virginia at Five*, 1990

for an album of 160 salt prints of Egypt made about 1851 by Felix Teynard. "Of the less than a dozen copies that exist in public or private hands," says Krauss, "none is in finer condition."

After two years of intensive work, Jill Quasha, a dealer known for assembling collections, has just completed the Quillan Collection. With just sixty-nine first-class prints, one picture per photographer, Quasha has undertaken to encompass a cohesive view of the medium from Fox Talbot to Édouard-Denis Baldus to Paul Strand to Christian Schad to Robert Frank to Harry Callahan to Richard Avedon to Cindy Sherman. Prices for the early prints ranged from $5,000 to $150,000, with an average cost of $25,000; the average price of contemporary works was $5,000 each. In celebration of the collection, the Quillan Company has published a book that reflects Quasha's lyrical vision of the medium.

Graham Nash built a collection of photographs taken before 1980, sold it in 1990 at Sotheby's for just under

$2,400,000, and promptly started a collection of contemporary photographs. He quickly made an exception to his guidelines, paying $165,000 for Edward Steichen's "Self-Portrait with Clara on their Honeymoon," made in 1903. Nash simply beams when describing the print, "I've always loved this picture, and when I actually saw it physically, I just fell for it hook, line and sinker. I'm from the north of England and pride myself on getting bargains. To part with $165,000 for a single image was quite shocking even to me. It was a total credit to the piece itself."

With numerous transactions at or near $100,000, "the top end of the market is disappearing," says Beth Gates-Warren of Sotheby's, and today's buyers are collectors who plan to keep the prints, not investors who plan to roll them over. "We were never able to sell to the yuppies," says Warren, "but it wasn't for lack of trying." Photography was too speculative they said, postwar West Side apartments were a far safer bet. Unfortunately, the yuppies never considered the possibility that all of their apartments would come on the market on the same day.

Prices exploded for the first time at the fall 1979 auction at Sotheby's Madison Avenue Galleries. Suddenly a Weston cost $10,000 and a Eugene Smith $1,500. Duane Michals attended the afternoon session to watch his portrait of René Magritte, estimated at $400 to $600, bring a hammer price of $1,200. He left grinning and shaking his head. The star of the show was the auctioneer, Lorna Kelly, a handsome blonde with a commanding presence. She kept the auction moving with an acid tongue punctuated by the then-ubiquitous Sotheby's English accent: "We'll have to hurry up; they're selling paintings tonight, as if anybody cares," and inspecting a Helmut Newton, "My, isn't he a naughty one."

However, not everything was peaches and cream for the Sotheby's girls in their flats and their pearls. A Muybridge picture of a waterfall was sold for an unheard of $4,200, but in all the excitement the signed auction chit was lost. The furious consignor consulted with attorney Arthur Bullowa, then president of Aperture, damning Sotheby's and fuming about the phony English accents. Bullowa dryly replied, "If any of those people

actually lived in England, they'd be delivering the mail."

Prices collapsed as a result of the 1981 recession. Ansel Adams's bellwether "Moonrise Hernandez" dropped at auction from a high of $16,000 to a low of $4,000 in a year and a half. Anyone paying $3,000 for a Man Ray in '81 was risking real money and had no reason to believe that he could resell the picture for half that amount, if he could resell it at all.

However, by late 1983 the Reagan economy had trickled down to the photography market. At Sotheby's that November, one of five extant prints of Charles Sheeler's "Wheels," 1939, drew spirited bidding. Tom Halstead, a dealer in Birmingham, Michigan, finally bought it for $67,100, acting on behalf of the Detroit Institute of Arts. The sale broke all records for photographs at auction and set a new standard for institutional purchases.

On June 8, 1984, the J. Paul Getty Museum changed the photography market forever by purchasing five major private collections, including the Samuel Wagstaff collection, for a sum reportedly in excess of twenty million dollars. Together with the four other collections, the Getty acquisition included 16,600 individual prints, 1,300 photographically illustrated books and albums with original mounted prints, plus approximately thirty thousand stereographs, cartes-devistes, and postcards.

The purchase followed months of delicate, secret negotiations by Daniel Wolf, the dealer who acted on behalf of the Museum. Weston J. Naef resigned from the Metropolitan Museum of Art to head the new collection and in a single day became the largest buyer of photographs in the world.

Suddenly the Damocles sword of these massive private collections was replaced by the appearance of scarcity. In the minds of collectors every vintage print now had a potential buyer. Since the 1984 purchase the J. Paul Getty Museum, at the direction of Weston Naef, has bought approximately 6,500 photographs and forty photographically illustrated books and albums.

In the fall of 1984 Peter MacGill, director of the Pace/MacGill Gallery in New York, mounted an exhibition of Paul Strand master vintage prints that had

been shown in 1916 by Alfred Stieglitz in his famous Fifth Avenue gallery, 291. In short order MacGill surprised even himself by selling a print at $50,000, then one at $75,000 and ultimately, a unique signed, platinum print of "Wall Street," 1915, to the Canadian Center for Architecture for $170,000. The following year, MacGill sold another example of the Sheeler "Wheels" for $92,500. In 1988 that same print, along with seven other Sheelers, was resold to the Getty by James Maroni who valued it at $130,000.

The fascination with vintage prints is a 1980s phenomenon. In the '70s many dealers and collectors, then dubbed by the guards at the Metropolitan Museum as the "subway set," believed that the history of art began in 1959 with the publication of *The Americans* by Robert Frank. A photograph was often sold on the condition that a new archivally processed print replace a dusty vintage print that might have a dent or smell of fixer.

As the boom market began to expand rapidly, Tennyson Shad, owner of the Light Gallery, saw photography as strictly a volume business and encouraged his best-selling photographers—Ansel Adams, Harry Callahan, and André Kertész—to engage in massive reprintings of their best-known images. Print quality suffered badly, particularly with Kertész who instructed his printer Igor Bakt to make the prints with more contrast to hide negative flaws. "The Melancholy Tulip" (reputedly a plastic tulip), was shot as a commercial sample in 1939 and published in 1972 by Inge Bondi in an edition of 150 with the negative "retired permanently." However, Kertész brought the negative out of retirement and subsequently reprinted the picture many hundreds of times, mostly as eight-by-tens, which became known in the trade as "investment size."

"The boom market was a revolution with all the foolish qualities of a revolution," says Anne Horton, former director of the Photography Department at Sotheby's and one of the principal architects of the photography market. Kertész was laughing all the way to the bank. Peter MacGill, then Director of Light Gallery, remembers that "every time I would hand André a check, usually for twenty or thirty thousand dollars, he would grab it, shaking it in his fist, yell-

Sally Gall, *Andrea*, 1989

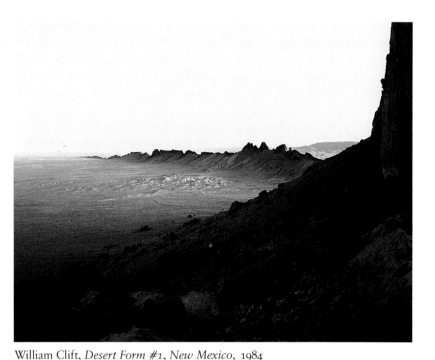

William Clift, *Desert Form #1, New Mexico*, 1984

HOT PIX: Sally Gall's use of the human figure in water was the surprise of the 1988 Houston Fotofest. Growing support from collectors has led to three exhibitions at New York's Lieberman & Saul Gallery.—PCJ

ing, 'I fool them, I fool them; they think I'm going to die, but I'm not.' " But when the market collapsed in 1981, no dealer would touch modern Kertész prints; they were treated like Eurodollars. For sellers, the only outlet was at auction where they would have to stand in line to sell, sometimes for years. "The rule was never more than eight Kertész prints in a sale," recalls Anne Horton, "a 'Melancholy Tulip' once every two sales."

In response to the modern print debacle, a market was established for vintage prints, which rarely existed in large quantities and often were unique. More importantly, to the sophisticated eye they were infinitely more beautiful. Phyllis Lambert, a renowned collector and founder of the Canadian Center for Architecture, had known the value of vintage prints all along. The same dealers who had been selling "Moonrise" were also offering vintage prints to CCA. With few buyers for architectural photographs, reprinting was never an issue. In 1983 Lambert mounted a first-class exhibition of the collection at the Cooper-Hewitt Museum and threw a spectacular opening party. For many of the dealers, who

had waited for the Fifth Avenue bus in rented tuxedos after Richard Avedon's opening at the Metropolitan Museum of Art, it was the first time they had tasted a hot hors d'oeuvre.

Today even modern prints have a strong market. Beth Gates-Warren says, "Most first-time and one-time buyers want a Kertész. The images are well known, attractive, and were made in Paris. People love photographs of Paris." The market for Ansel Adams photographs has returned, but not without bitterness. As many as two thousand prints of "Moonrise" may have been made, and those burned by the "yo-yo" market for his work have described his pictures of Yosemite "as looking like they came out of the black-and-white drawer of a stock photography agency."

However, internal squabbles have been tempered by a hot market with high prices. Suddenly, photographs are everywhere, stirring up endless controversy, offered by nearly every gallery at the Basel Art Fair, and called by the *Wall Street Journal* the greatest growth opportunity in the art market. Major galleries have followed the lead of Pace and Robert Miller, which represents McDermott & McGough and Jan Groover among others, as well as the photographic estates of Robert Mapplethorpe and Andy Warhol. Hirschl & Adler Modern, which until recently has been known as a painting

HOT PIX: William Clift is the foremost living photographer of the American landscape. His unique style has led to a unique marketing approach as well. William Clift's prints are available only through William Clift, P.O. Box 6035, Santa Fe, New Mexico.—PCJ

and sculpture gallery, has begun exhibiting photographic works by Paul Laster, Lynn Davis, and Josef Breitenbach. Assistant Director Frank Del Deo says that "photographs and photographically derived imagery have vastly expanded the artist's palette, permitting the expression of a broad range of ideas with extraordinary flexibility."

As a result of America's astonishing capacity to assimilate the avant-garde, even the Starn Twins have become mainstream artists. Yet contemporary photographs, the artistic equivalent of over-the-counter stocks, remain the most exciting play, with prices ranging from the low hundreds to the high thousands. Collectors can look forward to an unusual marketing dynamic as the work of the image manipulators collides with the medium's new formalists, exemplified by Joel Sternfeld, McDermott and McGough, and Sally Mann. However, Frank Del Deo isn't concerned. "Both can coexist; both can thrive," he says, because "artistically there is still so far to go."

People and Ideas

IMAGE AND IDENTITY IN WAR
By Robert Dannin

The idea that images are weapons of war is not new. The now-discredited view of ancient history depicted by Herodotus turned out to be an ethnocentric interpretation of certain events like the Peloponnesian Wars (431–404 B.C.). Herodotus was a skilled practitioner when it came to distinguishing between the civilized and the barbarous. But he was also dishonest. He reduced foreign peoples to savage brutes in order to mobilize the citizens of the Greek *polis* to support the principle of annihilating one's enemies.

What can be said about distant battles at other points in history? Will archaeologists argue forever over the verisimilitude of military exploits etched in stone? How was the phrase "cleared by the Pharaoh's military censors" rendered in hieroglyphics? Or would General Nguyen Vo Giap ever recognize a hint of truth in "Vietnam: A Television History," purporting to show the war in which he defeated the most powerful army on earth?

By themselves, photographic and television images do not represent progress in our ability to understand the truth and interpret reality. They are always and forever designed to create reality and legitimize particular truths. It is something inherent in their logic, the logic of representation, which causes images to serve as the mirrors that validate notions of identity—an identity that is temporal and exterior, revealing perhaps more about national character than about human values.

On the other hand, very few specific images manage to extricate themselves from historical reality and grow in the collective imagination. I can think of Picasso's "Guernica" for example. It lifts perception beyond the immediate. It accomplishes this by destroying violently an alleged reality, ripping it apart and penetrating it with the shock of fractured bodies, intermingling the human with the animal, the victimless executioners with the executed victims. "Guernica" represents an age, and ties itself to something universal in a way that Robert Capa's "Fallen Soldier" (from the same war), for example, cannot because of its intimate and graphic connection with a particular time and place. The former inspires us to generalize about the human condition. It becomes a symbol. The latter image conspires with facts to link our understanding to a particular set of historical events. It is a sign and an ideological one at that.

In considering the images of this recent war, it should come as no surprise that the most technologically advanced systems for creating and diffusing images are producing the least interesting kinds of pictures. Generally, they are banal. They lack aesthetic quality. Eventually, they are going to disappear. However, it would be irresponsible to conclude that they have no significance. We have to use them to discover something about the logic of identity and how it relates to the technology of social control to which we are being subjected. If not for today in the Persian Gulf then for tomorrow in preparation to stop the next war.

To begin with, there are at least two wars being waged, one out there in the theater of military operations and the other in here, in our minds. Each has a language of its own but also an immediacy that fuses both sets of events into simultaneous meanings. It is an interaction of those who actually are fighting the war and those who are watching it. The dividing line is quite ambiguous. This is a most dangerous tendency, because some of us are liable to think that wars can be fought without endangering lives or that the endangered lives are not real.

This first became obvious to me on February 15, 1991, when the arch-enemy announced his first, tentative decision to surrender. My immediate reaction was that of relief followed rapidly by an overwhelming sense of confusion. What was it that I wished to be over and done? Was it the real fighting, the SCUDS and the carpet-bombing? Or was it the relentless public-relations campaign being waged by our national emergency state? That is the war that refused to leave me alone,

wearing me down and blunting my perception when I turned on the television or looked in the papers. I guess the instincts were correct but there is a lingering uneasiness that my thinking about the war had been reduced to a selfish, interiorized dialogue.

Like every other business over the last decade, war reporting has been privatized and monopolized. That limits the extent of public discussion. It precludes teach-ins. We learn very little about the cultural values of the region. Doubters are isolated as dangerous sympathizers. The terrain is cleared so that the public-relations war can be conducted in a relatively sterile environment. And there are specific rules of engagement.

The twenty-four-hour live coverage is commanded by generals who employ all advertising techniques necessary to mobilize the population into a quasimilitary posture. News is piped in like gas and electricity. It becomes a public service.

Commercial product sponsorship still continues, its covert relationship with editorial content transformed into an open secret. Witness, for example, the conflated appeal to consumption and civic allegiance in recently published NYNEX ads. "Never is information more crucial to democracy than at times like these," reads the text. This message is preceded by a collage of images prominently featuring soldiers phoning home from the desert, nervous families, the stock exchange, satellite dishes, and the planet Earth. Using the telephone is no longer a choice one can exercise but a patriotic duty to be performed. "We're all connected," chants a jingle by a subsidiary of the same company—a kind of anthem to the Orwellian national emergency state.

There also has to be a format for the orderly consumption of war as a media event. Regular television series are replaced by shows like "War in the Gulf" or "America at War." There are titles, designed logos, fade-in and fade-out images like rolling tanks and streaking jets. Each network plays its own theme music, too. In style and structure their programs are

not that different from a miniseries, "The Winds of War," for example, a 1988 television adaptation of the Herman Wouk novel.

As for content, however, there is really nothing special in terms of particular images. It's what's missing that counts. The reporters are in Saudi Arabia. We constantly see their faces "live" across the time zones as if the mystery of distance can substitute for the absent images of that country. But what about showing the realities of war? Official media coverage has to rely on a strong, unambiguous narrative, which is achieved by combining spoken or written reports with a series of images, each of which is too weak to stand on its own but fits neatly into a videocast or magazine layout. By contrast, a strong picture like the rubble and human remains of a vaporized bomb shelter is disruptive. Like "Guernica," it threatens to become symbolic, interrupting the scripted flow of mundane images.

For this reason the controversy over the Baghdad bomb shelter became a war within a war. Although there was never any doubt that many Iraqi civilians perished, it was clearly this image of a mass incineration of human beings that forced us to see for the first time that the casualties could not be counted in terms of aircraft, tanks, government buildings, or oil wells.

When Saddam claimed that the coalition bombers had wantonly targeted a civilian shelter, he was simply inverting the logic of Bush, who maintained that the civilians were used as cover for military command operations. Both explanations focused on issues of inaccuracy or deception but neither really disputed the ultimate logic of warfare. It was a clash about the rules of the game without ever questioning the principles that governed that game. At stake was the power of mass support for war as a national enterprise. It had to be managed to contain any potential human emotions. That's why the Iraqi censors were as stingy with images of human remains as we were.

With fewer resources and less influence than television, the print media assumes the role of patriotic veteran, ready to plug any gaps in the line of battle. Nowhere is this caricature of the paunchy reserve battalion more apt than for *Life* magazine, which was embar-

rassingly resurrected as a weekly to engage in the duplicitous task of cheerleading and jingoism.

In three editions, *Life in Time of War* published seventeen full or double pages in which American flags were prominently displayed. Also there were eight full or double pages featuring children in unmistakably patriotic formations. Overall nearly twenty percent of the magazine's editorial space was consecrated to the most craven form of boosterism. Publishers, editors, and photographers alike were merely passing the buck down the line from the studio execs at Time-Warner. Promotional shots accompanied by filler copy, the standard Hollywood press kit. Where were the great ideas that made photojournalism unique?

As if to legitimize all this junk that his magazine published, the editor-in-chief sardonically asserted that "*Life* invented photojournalism" and invoked the names of W. Eugene Smith, David Duncan, Paul Schutzer, Larry Burrows, Margaret Bourke-White, and Carl Mydans. Well, *Life* may or may not have invented photojournalism, but certainly it is one of the pallbearers at the funeral.

A further illustration of the media's collaboration in the degradation of visual imagery is the brazen promotion of the U.S. defense industry.

Before the crisis began in August 1990, there was a widely publicized scandal over a U.S. Navy contract for a MacDonnell-Douglas fighter plane, the A-12. The company was ready to go bankrupt if the Pentagon insisted on the original budgeting plan. Production fell behind schedule and was halted. At first the Defense Department attempted to

bail out the manufacturer with a dose of tax-payers' money, using the excuse of national security. In a climate of bank failures and severe recession, however, it was politically untenable, and Defense Secretary Cheney eventually backed down.

There were lots of other problems with hardware in the trillion-dollar military arsenal. But when the SCUDS began to fly and the Patriots were deployed, the tarnished defense suppliers had a perfect opportunity to recast their public image. It was a case for technology to the rescue. The anti-missile missiles were unloaded in Israel on January 25th. The flash of Patriots defending Saudi Arabia and Tel Aviv became a familiar prime-time feature, even prompting BBC correspondents to call CNN "Scudvision."

On its February 18th cover, *Newsweek* published a picture of the F-117A Stealth fighter plane. The entire issue was devoted to promoting the defense industry, not to describing the war. Cruise missiles, M1A1 tanks, A-6 Intruders, B-52's were featured in the editorial pages and supplemented by a four-page glossy pullout entitled, "The Allied Firepower"; on the flip side: "Saddam's War Machine." It resembled a copy of *International Defense Review*, a monthly trade publication that prints many of the same eight-by-ten glossies furnished free of charge by the manufacturers.

In a graphic summary of the first week of Desert Storm, NBC aired six different images on "Today At War." They were a Tomahawk ship-launched cruise missile; eerie green footage of the night bombing of Baghdad; fighter pilots returning from attack missions; simulations of chemical and tank warfare in the desert; and rub-

Left: CNN's "War in the Gulf," the longest-running and most successful miniseries in the history of television. Right: The A-10 Thunderbolt, or "Warthog," everyone's favorite tank-killer.

ble from a SCUD attack on Tel Aviv. In the following days, these select image categories would become icons, to be used and reissued in the media as regularly as the military commanders held press briefings. It is instructive to analyze these categories, point by point.

First, the hardware. Clean, gleaming. Functions perfectly. The most graceful variation on this theme was the mid-air refueling of an F-18A. Heavy-metal co-itus. The deadliest variation was video footage of cruise missiles screeching overhead en route to targets somewhere in Baghdad. On February 4th, CNN broadcast this clip five times between 8 a.m. and noon. It was interspersed with speeches by Bush at three military bases in the South.

Second, the target. The enemy's lair as vile and spooky, hued in green, the unfocussed object of the inhuman eye of a "smart" bomb. The coalition generals were particularly fond of screening these barely perceptible videos which actually had movie-like titles such as "F-15 vs. Foxbat," "Destruction of Mobile SCUD Launchers," or "The Luckiest Man in Iraq," where a speeding car narrowly escapes a laser-guided bomb. On the second day of the air campaign, January 19th, the *New York Times* published two one-column smudges (page 9A) supposed to be the aiming and destruction of an enemy SCUD installation as seen through the cross-hairs of an F-117 fighter. The enemy became a blur without distinguishing characteristics. Believe the caption. There is no image at all.

Third, the warrior or dashing flying ace departing on a dangerous mission. A few of these unfortunate heroes made unexpected guest appearances on enemy television as POWs. Their colleagues on the ground were tank commanders, but the armor, goggles, and gas masks concealed their personality and were not very sexy.

One of the only true combat scenes of the war fell into the "warrior" category also. During an intense battle for the city of Khafji on January 28th, CNN interviewed a Marine artillery commander. As howitzers dueled furiously across the desert, Marines loaded 105-mm shells and plotted their targets. The big guns blazed away. A supply truck with fresh ammo pulled up. It was unloaded hastily. Firing continued. Explosions and whistling shells flew overhead. The commander issued a series of orders to his men, each phrase punctuated with the expletive, "Fuck!" His subconscious must have been working overtime, for he concluded the interview saying, "It feels good. We want to destroy them."

Simulated combat and deployment comprised the fourth and fifth categories of war coverage. Aesthetically meaningless and incapable of conveying the real texture of warfare, such images referred directly back to the hardware and the warriors. They also provided the raw materials for virtual reality, in which the military experience is reproduced minus the risk. All the thrill of battle but in the safety of one's home . . . kind of like phone sex.

Finally, the bombing, death, and destruction was almost completely sanitized. No dead GI's. Not even any coffins returning to Dover Air Force Base in Delaware, which was declared off-limits by the Pentagon in the early days of Operation Desert Shield. Wherever disjointed bodies lay in the rubble of an explosion, as in Baghdad, the glue that holds the image to the sign weakened. The icon needed to be reinforced by media managers.

In the papers and magazines these managers formed a legion of one-column-portrait generals, commanders, foreign dignitaries, and local politicians. On television they fought alongside the ever-present anchors, commentators, and spin-doctors. Ladies and gentlemen, salute your superior officers! They will describe the war and analyze it for you. They shall construct scenarios or battle plans on maps and electronic charts. They shall reconstruct the events which your low rank did not allow you to see. They will control the images, their rhythm and supply, their content and their form, their resolution and their density. If you see images of broken bodies and shattered civilizations, don't panic! You don't know any of these people. They don't look like you and me. Fear has an address, but relax, it's nowhere near *your* neighborhood.

One of the conclusions we can draw from this experience is that the rationale of technology has become dominant. It governs the information media autocratically. It has emptied the televisions, newspapers, and magazines of any real content. Its messages are increasingly limited to ones that express some aspect of mechanical or technological data. Whereas increased knowledge was supposed to humanize our experience, this mass-information culture moves in the opposite direction, breeding a population of reduced, one-dimensional beings—a vast network of interconnected ganglia eagerly exchanging pre-programmed bytes.

Left: Nighttime bombing of Baghdad: the enemy's lair portrayed as an off-planet location. Center: A January 28th artillery duel on the outskirts of Khafji, Saudi Arabia, provided one of the few combat scenes broadcast to the public. Right: Smoldering ruins of an alleged civilian bomb shelter hit by coalition bombing on the night of February 12.

CONTRIBUTORS

WERNER BOKELBERG was born in 1937. He has been photographing for thirty-five years, ten of which were spent with *Stern* magazine. He has been collecting actively since 1970. A short film on photographic history and appreciation titled *Every Eye Forms Its Own Beauty* features the Werner Bokelberg collection and was made by his son, Oliver Bokelberg, who also was of great assistance in preparing our interview with his father. For further information about the film, contact Oliver Bokelberg at (212) 505-2239.

STANLEY B. BURNS, M.D., an ophthalmologist and surgeon, has compiled the nation's largest collection of early (1840–1940) medical photography. He recently co-edited a book on the subject with Joel-Peter Witkin titled *Masterpieces of Medical Photography*. The Burns Archive is officially recognized by the State of New York as a cultural institution. It is open to the public free of charge, by appointment only. Tel: (212) 889-1938.

ROBERT DANNIN has a Ph.D. in Ethnolinguistics, Social and Cultural Anthropology. He is former Editorial Director of Magnum Photos, Inc. Currently he is working as a freelance journalist and commentator.

ARTHUR C. DANTO is Johnsonian Professor of Philosophy at Columbia University and art critic for the *Nation*. He has published many books on philosophy and art. In 1985 he was awarded the Manufacturers Hanover/Art World Prize for Criticism, and in 1986 he received the George S. Polk Award. He lives in New York City with his wife, the artist Barbara Westman.

PETER C. JONES is a fine-art agent, photographer, and author. He has organized numerous exhibitions throughout the United States and Europe. He is the photographer for *Social Gardens*, published by Stewart, Tabori & Chang, and the author of *The Changing Face of America*, to be published in the fall by Prentice Hall Editions.

GÉRARD LÉVY is an expert on Oriental Art. In 1955 he met André Breton and Man Ray, both of whom profoundly influenced his vision. He has a gallery in Paris and is the official court expert on photography in France.

HARRY LUNN began collecting art in the early 1960s and opened his first gallery in Washington in 1968. He was made a member of the Art Dealers Association of America in 1973, assisted in the organization of the Association of International Photography Art Dealers in 1979, and is a member of the AIPAD Board of Directors. Mr. Lunn became a private dealer in 1983 and is based in New York and Paris.

DOROTHY NORMAN was born in Philadelphia in 1905; she came to New York in 1925 and began a distinguished career as editor, publisher, columnist, writer, and photographer. She was closely associated with Alfred Stieglitz from 1927 until his death.

JOSHUA P. SMITH is a leading authority on and a collector of avant-garde photography and photojournalism. He was guest curator of "The Photography of Invention: American Pictures of the 1980s," at the National Museum of American Art; the Museum of Contemporary Art, Chicago; and the Walker Art Center.

THOMAS WALTHER is a collector who lives in New York and Berlin.

CREDITS

Front cover: photograph by André Breton, courtesy of the Gérard Lévy collection; p. 3 photograph by Tina Modotti, sepia-toned platinum print, courtesy of Sotheby's; pp. 4-15 photographs courtesy of the Werner Bokelberg collection; p. 16 photocollage by George Tourdgman; pp. 17-25 photographs courtesy of the Gérard Lévy collection; p. 22 silver-bromide print, photographer unknown; pp. 23-25 albumen prints from glass-collodion negatives, photographer unknown; pp. 26-35 photographs courtesy of the Joshua Smith collection; p. 33 photograph by Daniel Borris; pp. 36-45 photographs courtesy of the Stanley B. Burns Archives; p. 38 daguerreotype of a young girl, photographer unknown; p. 45 daguerreotypes, photographer unknown; p. 46 photograph by Gustave Le Gray, courtesy of Lunn Ltd.; p. 47 Rayograph by Man Ray, courtesy of One Bond, Inc./ Michael Senft; p. 48 Cibachrome by Andres Serrano, courtesy of Stux Gallery; p. 49 palladium print by McDermott & McGough, courtesy of the Robert Miller Gallery; pp. 50-55 photographs courtesy of the Dorothy Norman collection; pp. 51, 52, and 55 photographs of Mrs. Norman's home by Patty Wallace; pp. 56-67 photographs courtesy of the Thomas Walther collection, vintage silver and platinum prints; p. 68 photograph by Sally Mann, courtesy of Houk Friedman Gallery, New York; p. 70 left: photograph by Sally Gall, courtesy of Lieberman & Saul Gallery, New York; p. 70 right: photograph by William Clift, copyright by and courtesy of the artist; pp. 72-73 photographs by Jolie Stahl, copyright by and courtesy of the artist.

PHOTOGRAPHERS AT WORK A SMITHSONIAN SERIES

**NIXON • BARNEY
MEYEROWITZ • MARK
MAISEL • GROOVER**

*Developed and produced by
Constance Sullivan*

"An inside look at how photographers work
and think, this new series offers a rare and
desperately needed middle ground
between critical and instructional tracts."
—*American Photo*

Six volumes profiling the work
and working philosophy of major
contemporary photographers.

**Nicholas Nixon
FAMILY PICTURES**

In these never-before-published portraits
of people including those of members of
his family, Nixon uses the large-format
camera and contact print methods favored
by Edward Weston and Walker Evans.
30 duotones 64 pp.
Paper: 1-56098-049-4 $15.95

**Tina Barney
FRIENDS AND RELATIONS**

When she emerged in the photography
world in the mid-1980s, Tina Barney
immediately drew attention and acclaim
for her large-frame, intensely hued
tableaus of upper-crust life. Using a tripod
and a 4 x 5 inch view camera, Barney
saturates her film with the intimate
moments and underlying tensions of
family life.

30 color illus. 64 pp.
Paper: 1-56098-048-6 $15.95

—————— Also in the Series ——————

**Joel Meyerowitz
CREATING A SENSE
OF PLACE**
29 color illus. 64 pp.
Paper: 1-56098-004-4 $15.95

**Jay Maisel
ON ASSIGNMENT**
30 color illus. 64 pp.
Paper: 1-56098-002-8 $15.95

**Jan Groover
PURE INVENTION:
THE TABLETOP
STILL LIFE**
23 duotones 64 pp.
Paper: 1-56098-005-2 $15.95

**Mary Ellen Mark
THE PHOTO ESSAY**
28 color, 2 b&w illus. 64 pp.
Paper: 1-56098-003-6 $15.95

———————— Other Photography Titles ————————

CARRY ME HOME
LOUISIANA SUGAR COUNTRY IN PHOTOGRAPHS BY DEBBIE FLEMING CAFFERY

"Superb. . . .The earliest of these photos
have the feel of classic documentary
images of rural life. . . .The atmosphere
she creates is somehow mythic, almost
supernatural." —*Village Voice*
80 duotones 150 pp.
Cloth: 0-87474-299-4 $35.00
Paper: 0-87474-311-7 $19.95

HARLEM
PHOTOGRAPHS BY AARON SISKIND, 1932–1940
Introduction by Maricia Battle
Text from the Federal Writers Project,
edited by Ann Banks
"[Siskind] deserves a reputation as a first-
class documentary photographer. His
portraits of Harlem's poor are the product
of an individual vision."—*New York Times
Book Review*
45 duotones 80 pp.
Paper: 1-56098-041-9 $14.95

**SMITHSONIAN
INSTITUTION
PRESS**
Dept. 900
Blue Ridge Summit, PA 17294-0900
**800/782-4612
717/794-2148**

CONTEMPORARY PHOTOGRAPHY

HOW *WHAT* WHERE *WHEN* WHY

read the CENTER *Quarterly* / find the questions / find the answers
an accessible magazine for curious artists and audiences

last year we featured provocative essays
on photography and science by Ellen K. Levy, Robert C. Morgan, Berta Sichel, Gary Nickard,
Regina Vater . . . *and environmental issues* by Peter Goin, Deirdre Boyle, Charlotte Kinstlinger-Bruhn,
Jay Townsend . . . *and still life* by Charles Giuliano, Ellen Handy . . . *and social issues* by Fred Ritchin,
Robert Atkins, Sophie Rivera, Ann Meredith . . .
and fresh images
by Patrick Nagatani, Tim Rollins + KOS, Greenpeace photographers, Daniel Faust, Catherine Wagner,
Peggy Cyphers, Orsolya Drozdik, Joan Fontcuberta, Eve Laramee, Richard Ross, Hiroshi Sugimoto,
Lynn Geesaman, Nancy Burson, Olivia Parker, James Wojcik, Argentinian photographers,
Pablo Delano, Pat Ward Williams . . .

upcoming essays: Julia Ballerini, *The Surrogate Figure* / Robert Mahoney, *Old Photos: Inherent Vice*

opportunities / calendar / books / news / workshops
Kathleen Kenyon, editor / published four times a year / available by subscription
$25/USA • $40/Canada & Mexico • $45/International • MC/Visa

The Center for Photography at Woodstock, 59 Tinker Street, Woodstock, New York 12498 / 914-679-9957

© 1986 David La Chapelle

Boulder and Metamorphosis Wave
© Bruce Barnbaum, 1987
KODAK TRI-X Pan Professional Film

If there is any way for me to

THE

express my feelings about the

IMPACT

magnificent qualities of our

OF

earth, or to have any voice in

BLACK

the preservation of these quali-

AND

ties, it is through the medium

WHITE

of black-and-white photography.

No other means of expression

can create such impact so

eloquently.

BRUCE BARNBAUM
User of Kodak black-and-white
materials for 20 years.

PROFESSIONAL

PHOTOGRAPHY DIVISION

© Eastman Kodak Company, 1991

To more and more people,
Rollei performance is out-of-this-world...

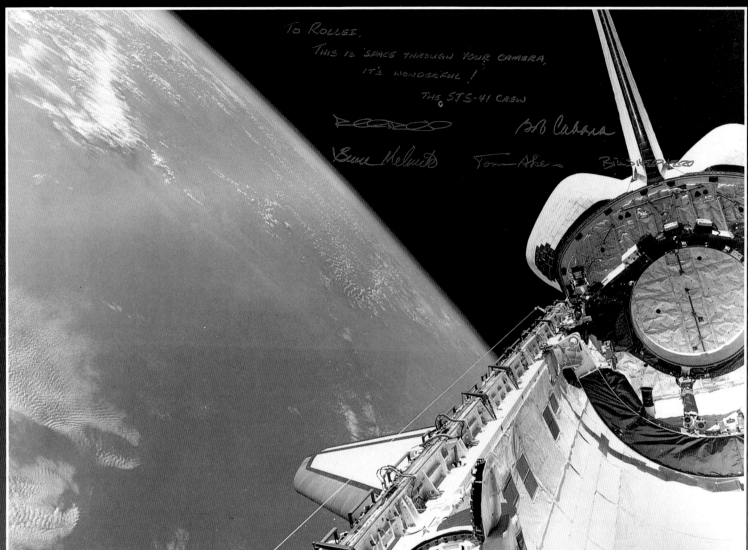

To Rollei,
This is space through your camera,
It's wonderful!
The STS-41 Crew

...especially on earth.

PHOTO A

PHOTO B

PHOTO C

What the Rollei Professional 6008 does on Space missions for NASA, it will do on earth for you. NASA uses the same off-the-shelf 6008 you can. With no adjustments or modifications. Some Rollei 6008 features are not even available on ultra-sophisticated 35mm cameras...and certainly not on any competitors' medium-format cameras (even their latest)! These features make your jobs better and easier. No matter what kind of space you shoot in, isn't it time you discovered what more and more of your peers already have?

• Built-in 2 FPS motor; • Auto-Bracketing—your shot plus 2 more: +2/3EV and −2/3EV to ensure proper exposure (just switch S± as shown in Photo A); • 3 Metering Modes (see Photo C)—Center-weighted multi-zone; Spot; and sophisticated Multi-Spot (reads and averages up to 5 different spots); • Aperture-priority AE, Shutter-speed priority AE, Programmed AE, Manual Modes; • Shutter

speeds and apertures in 1/3 stops; • Multiple exposure control (see Photo C); • TTL exposure metering in camera body to ensure consistent readings with all finders, screens and lens attachments; • TTL flash exposure with OTF readings and automatic ratioed fill flash (see Photo C) • Leaf shutter speeds from 1/500 to 30 sec. and flash sync over the entire range (up to 1/800 with some lenses); • Switchable viewfinder LEDs outside of frame area (see Photo B); • Interchangeable film magazines with film speed input, pre-loadable film inserts, and built-in darkslides; • Ergonomic design; • Extensive selection of world's finest lenses from Zeiss and Schneider (including a 180 f2.8 that's changing the look of photography); • CCD digital scanning back with 32,000,000 pixel resolution for PCs and MACs; • and so many advanced accessories (up to 59 hours 59 minutes timer; multiple-exposure remote control unit for stroboscopic effects, motion analysis; TTL flash meter), whole new worlds will open up to you—without leaving the planet.

Marketing Corp.
16 Chapin Rd., Pine Brook, NJ 07058, 201/808-9010

Rollei
fototechnic

We're looking at things from your point of view.

Lifetime Warranty

Apo-chromatic lenses.
Some "plane" talk from the people
who make the most.

Rodenstock has been making apo-chromatic lenses for almost 5 decades. So, not surprisingly, we offer the world's most extensive selection. Apo-chromatic large-format lenses provide pinnacle performance for the most demanding of photographers. They focus all wavelengths of the visible spectrum at the film plane. Thus yielding sharper, more highly defined images; both in color and black & white. Rodenstock offers 18 Apo lenses. Including Apo-Sironar, Apo-Ronar and the Sironar-N series.

Lateral Chromatic Aberration, Corrected.

The Apo-Sironar series includes our latest and most highly advanced Apo's: the 150mm and 210mm. At f22, they cover 80° delivering image circles of 252mm with the 150mm 5.6 and 352mm with the 210mm 5.6.

They have reduced distortion and eliminated color fringing more than hitherto possible. Rodenstock has corrected the lateral chromatic aberration of the secondary spectrum to 0.03% of the focal length! Yet this major optical breakthrough is achieved in surprisingly small and lightweight sizes. Copal, Compur or Prontor professional shutters are all available—and the prices of these lenses are very competitive. Compare them and their technical advantages. As with all Rodenstock large-format lenses, our Apo's have a Lifetime Warranty.

Rodenstock's superior quality and quantity of "taking" and enlarging lenses give you the greatest chance to solve *any* photographic problem—without sacrificing *any* quality. Come to your Rodenstock dealer and get more "plane" talk.

Marketing Corp.

16 Chapin Rd., Pine Brook, NJ 07058, 201/808-9010

In Canada: Daymen Photo Marketing Ltd., Scarborough, Ontario M1V2J9

Rodenstock
The world's greatest depth of quality.

NUCLEAR LANDSCAPES

Peter Goin

"The convergence of beauty and horror in this sensitively illustrated tale of contemporary exploration in landscapes fraught with danger gives new meaning to the Romantic notion of the sublime."—Graham W. J. Beal, Director, Joslyn Art Museum

65 color, 28 b&w photographs, 3 maps
$29.95 *paperback* $59.95 *hardcover*

THE JOHNS HOPKINS UNIVERSITY PRESS

701 West 40th Street, Suite 275, Baltimore, Maryland 21211
Available at your bookstore or call **1-800-537-5487.**

BRAVO 20

THE BOMBING OF THE AMERICAN WEST
Richard Misrach with Myriam Weisang Misrach

Winner of the PEN Center USA West Award for Non-Fiction

"These photographs have that sense of horrible fascination you find in photographs of atrocities. You can't stop looking at them, but you wish you could."—James Crumley, *Los Angeles Times*

40 color, 9 b&w photographs, 67 drawings and maps
$25.95 *paperback* $49.95 *hardcover*

THE JOHNS HOPKINS UNIVERSITY PRESS
701 West 40th Street, Suite 275, Baltimore, Maryland 21211
Available at your bookstore or call **1-800-537-5487.**

Two Alexandras, Gaëlle, Jeanne and Marine; Montalivet, France, 1987

JOCK STURGES

STANDING ON WATER

Standing On Water is a portfolio of 10 oversized silver gelatin prints published by the Paul Cava Gallery in an edition of 40 with 6 artist proofs.

Sturges is one of America's foremost photographers of the nude. His work is represented in many important public collections including the Museum of Modern Art, the Metropolitan Museum of Art, the Fogg Museum and the Bibliotheque Nationale.

For details and viewing please contact the

PAUL CAVA GALLERY
22 N. 3rd St., Phila., PA 19106
Telephone 2 1 5 - 6 2 7 - 1 1 7 2